WOKING IN 50 BUILDINGS

MARION FIELD

AMBERLEY

About the Author

Marion Field trained as a teacher and taught for several years in England before taking up a post in Canada teaching in a high school. After four years, she returned briefly to England and then went to Uganda where she taught English as a second language in an African girls' boarding school. Returning to England after two years, she continued to teach while studying for an Open University degree. Completing this, she took a post as a Head of English in a comprehensive school.

After several more years teaching, she took early retirement so that she could concentrate on writing. She writes biography, local history and books on the English language. *Woking in 50 Buildings* is her twenty-second published book. She has greatly enjoyed doing the research for a number of local history books and loves visiting other countries to learn about their cultures.

She is an active member of her local Anglican church. She has a professional acting diploma and enjoys acting with a local dramatic society. In her spare time she enjoys reading, playing tennis and travelling. She recently visited Australia.

First published 2017

Amberley Publishing, The Hill, Stroud
Gloucestershire GL5 4EP

www.amberley-books.com

British Library Cataloguing in Publication Data.
A catalogue record for this book is available from the British Library.

ISBN 978 1 4456 6538 2 (print)
ISBN 978 1 4456 6539 9 (ebook)

Origination by Amberley Publishing.
Printed in Great Britain.

Contents

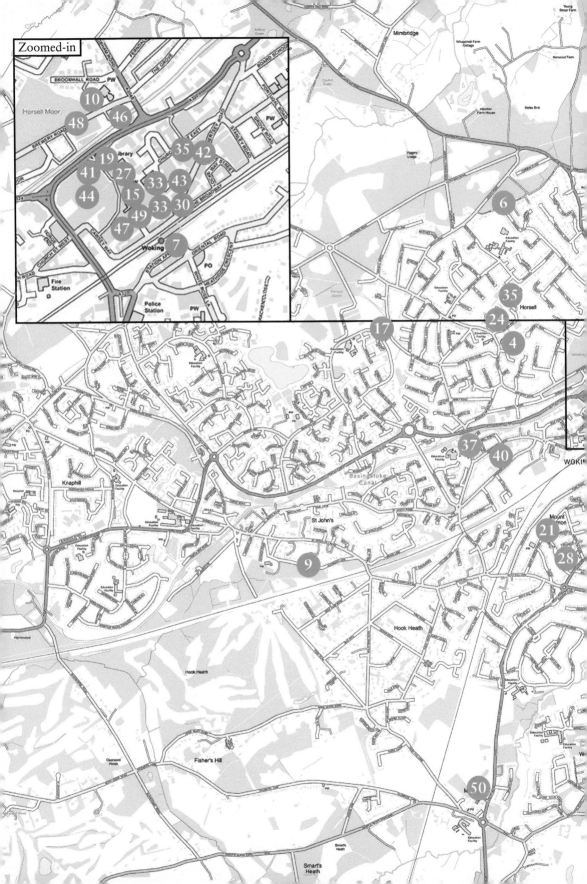

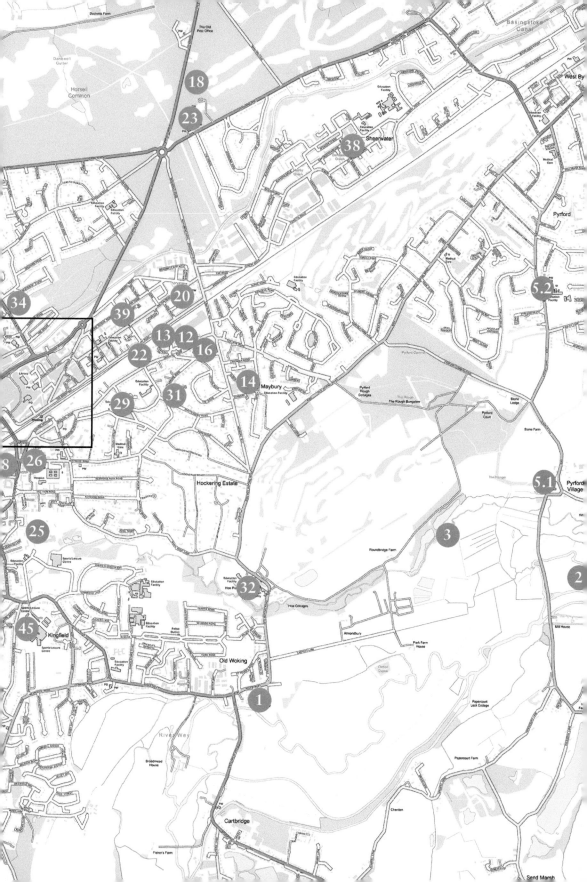

Key

Introduction

Until the middle of the nineteenth century what is now known as 'Woking' was simply a vast area of common land. However, Wochingas, the Saxon name for what is now 'Old Woking', was populated by the Saxons as long ago as the seventh century. An eighteenth-century document refers to a minster founded by Brordar, a Saxon nobleman, in AD 625. A wooden church was later built to replace it.

When William I took control, he built a new stone church on the site. A flourishing congregation still worships today in the twelfth-century St Peter's Church. The monks from the now-ruined Newark Priory would have worshipped in St Peter's. The manor of Woking was in the Royal Forest of Windsor and the king enjoyed hunting there. It was probably sometime in the thirteenth century that a manor house was built in the vicinity of St Peter's Church. In the fifteenth century Lady Margaret Beaufort, the mother of Henry VII, inherited the manor of Woking and transformed the manor house into a luxurious palace. When she died, it was inherited by her grandson, Henry VIII, who was a frequent visitor.

Sadly, today the palace is a ruin. It had been sold by James I to Sir Edward Zouche, who allowed it to fall into disrepair. He then demolished it and used the bricks to build himself a mansion on the site of the present Hoe Bridge School.

When, in the nineteenth century, it was decided to build a railway from Nine Elms (Vauxhall), it terminated at Woking Common before being extended both ways. In the 1830s when a cholera epidemic in London closed the churchyards, a new burial ground had to be found outside the capital. What better place than Woking with its new railway line and acres of empty land? A special line was constructed to carry the coffins to the new cemetery, which is still in use and now known as Brookwood Cemetery.

With the increased traffic, a town gradually emerged on what had been common land. Originally it was planned to build the town on the south side of the railway line and a station was built with the main entrance on the south side. Unfortunately in 1857 much of this land had been bought by John Raistrick, a wealthy railway contractor. His son, George Raistrick, an eccentric solicitor, later refused to sell any of the land for redevelopment.

Consequently the town grew up in a rather haphazard fashion on the wrong side of the station! The Railway Hotel was the first building to be built. This was followed by shops, more hotels and churches. A few of these buildings still remain but many have been demolished and it is hard to identify the original sites. Those that remain have often changed their original purpose and have taken on another role.

During the twentieth century Woking underwent a number of 'redevelopments' and this has continued into the twenty-first century. It has not been an easy task to find fifty buildings!

Twelfth Century

1. St Peter's Church

St Peter's Church in Old Woking is the oldest building in the area. A wooden Saxon church originally stood on the site, but in the latter part of the eleventh century William I demolished this and built a new stone church. The huge west door made of oak is the only remaining part of the Saxon church. This contains Anglo-Saxon motives including an iron cross. The church was enlarged in the thirteenth century when the south aisle was added.

One of the seventeenth-century parishioners was Sir Edward Zouche, to whom James I had granted the manor of Woking in 1618. While demolishing Woking Palace, he was determined to leave his mark on St Peter's Church. At the west end of the church he built a gallery so that parishioners, seated above the rest of the congregation, could see the preacher. He also enlarged the pulpit, which became a three-deck hooded version. It was

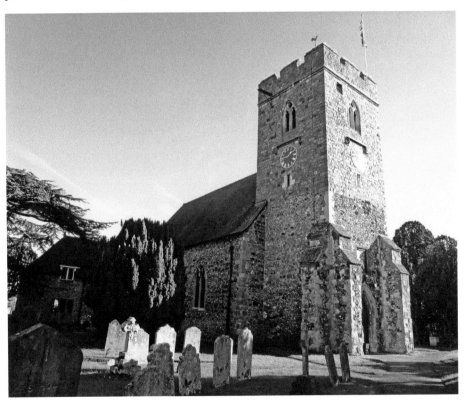

St Peter's Church, Old Woking.

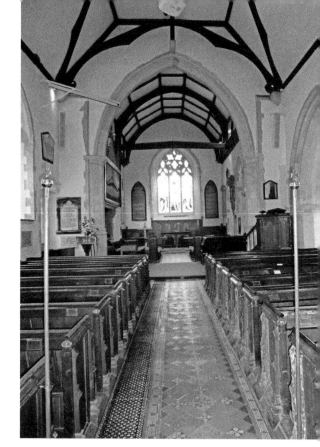

Inside St Peter's Church.

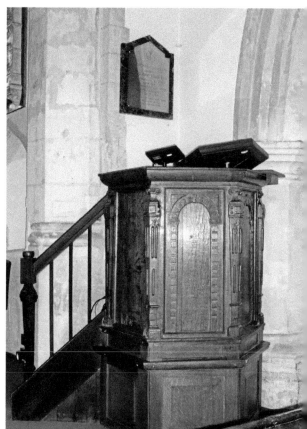

The pulpit in St Peter's.

from this that on 28 August 1627 a royal visitor, Charles I, heard a three-hour sermon. In 1918 the lower sections were removed. The top section was retained and forms the present pulpit, which is still in regular use.

The logo of St Peter's Church was created by Colin Lewis. In the centre is the figure of St Peter as he appears in the stained-glass window on the south wall. Surrounding him are the names of the three churches of which the incumbent is the rector. At the four corners of the logo are symbols linked to St Peter: at the top right the two crossed keys represent the 'keys of the kingdom' given to the apostle Peter; the cockerel on the left is a reminder of St Peter's denial of Christ; the three fishes at the bottom on the left-hand side were ancient symbols of Christianity; and the fishing boat on the right represents the disciple's occupation and also his role to 'fish for men'.

Regular concerts by talented musicians are often held in the church. There is a church hall immediately opposite the church beside a small car park. A variety of activities catering for all ages are held during the week.

2. Newark Priory

Newark Priory, near the southern boundary of Pyrford, was founded in the twelfth century by Ruald d'Calna and his wife, Beatrice de Saudes. They dedicated it to the Virgin Mary and the martyred Thomas à Beckett. It became a house of Augustinian canons and the monks would have worshipped at St Peter's Church. Excavations in 1928 showed that the church was cruciform with cloisters, a kitchen and a farm. The gatehouse and tower were separate.

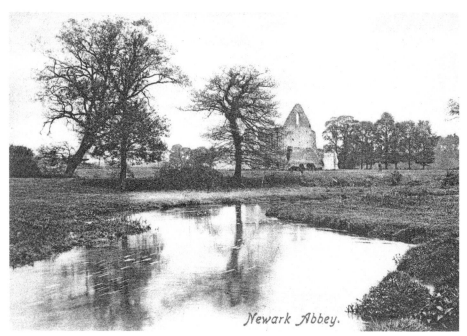

Newark Priory in the past.

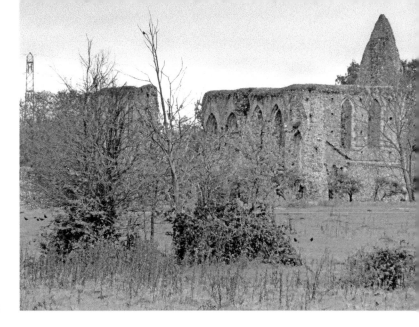

Newark Priory today.

In 1538, like most abbeys at the time, it was dissolved by Henry VIII. All that now remains is the south transept, part of the south wall and part of the north chapel. The ruins, a 'Scheduled Ancient Monument', are bordered by the River Wey and the Abbey Stream. The ruins lie in a deserted field owned by a local farmer. Permission to visit the abbey has to be obtained so usually the ruins can only be viewed from a distance.

However, every year on Easter Sunday, a 'Sunrise Service' beside the ruins is led by the vicar of the church of the Good Shepherd in Pyrford. On 14 June 1967 Newark Priory became a Grade I-listed building.

3. Woking Palace

In 1086 the manor of Woking passed to William I and in 1189 Richard I granted it to Sir Alan Basset. Sir Alan probably built the first manor house in the middle of the deer park so the lord of the manor and his guests would be able to indulge in the popular sport of hunting.

Over the next 300 years the manor changed hands several times and subsequent owners gradually enlarged the manor house until by the fifteenth century it was 'substantial' enough to accommodate over a hundred guests. In 1466 Lady Margaret Beaufort, the mother of Henry VII, and her third husband, Henry Stafford, were granted the manor of Woking and lived in the manor house.

When Henry Stafford died in 1471, his widow married Lord Thomas Stanley; they continued to live in the sprawling manor house. When Henry VII came to the throne in 1485, he spent a great deal of time with his mother in Woking. He transformed the manor house into a royal palace. In the centre of the area, he built a Great Hall and added other buildings around it. His mother was greatly attached to Woking and it was in the palace that she died in 1509. Her grandson Henry VIII continued to improve the palace.

He built new apartments for the king and queen, a large kitchen, stables and other buildings around a central courtyard. Henry enjoyed entertaining and three of his wives – Anne Boleyn, Catherine Howard and Catherine Parr – visited Woking Palace.

After his death, neither Edward VI nor Mary I showed much interest in the palace. Their sister Elizabeth, however, made her mark on the area. She demolished and rebuilt sections of the palace. When she died, her successor, James I, let the buildings deteriorate. In 1620 he granted the manor of Woking to Sir Edward Zouch. Sir Edward did nothing to restore the palace, allowing it to crumble into a ruin. However, he used some of the bricks to build himself an impressive mansion, Hoe Place, around a mile from the palace site.

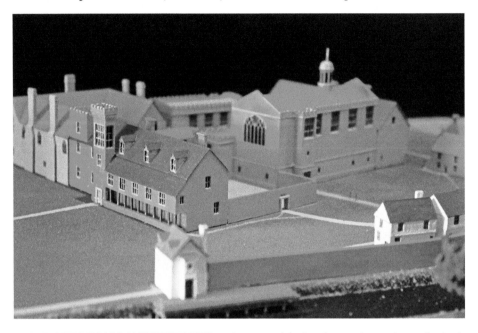

Above: Model of Woking Palace. (Photo Elizabeth Ransom)

Left: Tiles from Woking Palace. (Elizabeth Ransom)

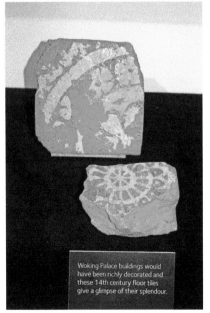

Woking Palace buildings would have been richly decorated and these 14th century floor tiles give a glimpse of their splendour.

Woking Palace artefacts.
(Elizabeth Ransom)

4. St Mary the Virgin Church

St Mary the Virgin Church in Horsell is a Grade II-listed building with a graveyard adjoining it. A stone chapel on the site was probably built in the middle of the twelfth century. The church was rebuilt early in the fourteenth century. Parts of the roof of the nave and the west wall may be from the earlier period. The aisle was built mainly of carstone and the tower of flint, clunch and heathstone. The medieval doors with their original hinges, latches and ironwork are still at the west end of the church.

Two iron spits were recorded in 1552; they would probably have been used to roast an ox or pig on special festivals. The remains of one of them can still be seen. Another reminder of past days is the fifteenth-century oak chest situated at the end of the north aisle. The one in the porch is from the following century. The south aisle was added in the fifteenth century and the oak pulpit was installed in 1602. The six bells were established in the eighteenth century and still ring every Sunday and on other special occasions.

More building work to enlarge the church took place during the following centuries. In the eighteenth century the chancel was rebuilt in brick; the nave and south aisle were extended eastwards in the nineteenth century when the Gothic screen was removed. The twentieth century saw the addition of the north aisle and the Trinity Chapel. In 1921

the baptistry was added and the font took up its traditional position by the west door. The remains of two earlier stained-glass windows can be seen on the outside wall of the baptistry. The larger one dates from 1320 while the smaller is from the middle of the fifteenth century.

More space was needed as the congregation grew and in 1987 a large room was built adjoining the church. It was named St Andrews as part of it was funded from the sale of the nearby St Andrew's Church. This was rebuilt in Goldsworth Park.

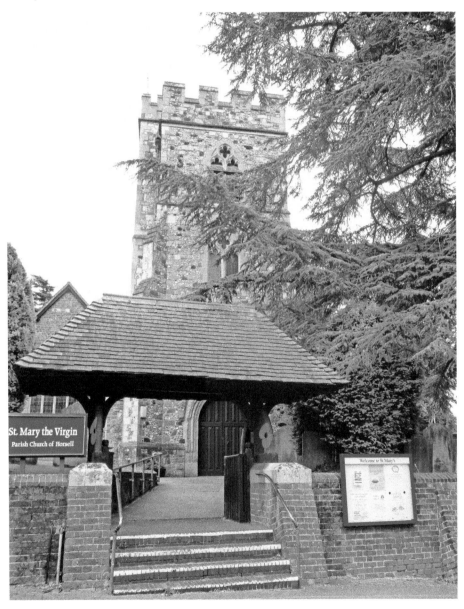

St Mary's Church, Horsell.

5. Churches in Wisley With Pyrford

In the eleventh century the manor of Pyrford was held by the king. The name means 'the ford by a pear tree'. It was in AD 698 that the name 'Pyrford' first appeared in a document of the time. The Church of St Nicholas was built on a hill near the village in the twelfth century. Unlike many other medieval churches, it has had no additions over the centuries and seats no more than 100. Elizabeth I often visited Pyrford and attended services at the local church. Tradition says that she once presented it with a small chalice, which is now in the safe keeping of the treasury at Guildford Cathedral. When restoration work was carried out in the nineteenth century, some interesting frescoes were discovered on one of the walls. Three original consecration crosses can also still be seen. Its faithful congregation still worships regularly in the twenty-first century.

In 1762 the parish of Pyrford was joined with Wisley. As a church in Wisley was mentioned in the Domesday Book, it is likely that there was a building on the site before the present church was built in the twelfth century. It, too, houses only a small congregation and is still in regular use. Three of the original consecration crosses can still be seen.

With the population of Pyrford expanding in the twentieth century, the site for a new church was purchased in 1936. However, the advent of the Second World War hindered the building, which did not start until 1962. The 'Church of the Good Shepherd' was consecrated in 1964 and it had a seating capacity of 600. In 2000 an extra chapel was added to celebrate the millennium and in 2005 the facilities were enlarged to provide extra rooms and a larger hall. The church is a hive of activity throughout the week as it caters for its large congregation of mixed ages and also the wider community. Regular services are held on Sundays with an occasional family service at 4 o'clock followed by tea and cake. There are men's curry evenings, women's breakfasts, a youth club and children's activities.

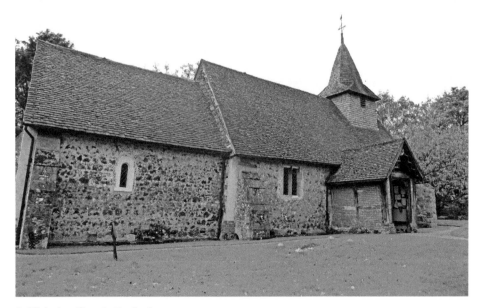

St Nicholas Church, Pyrford.

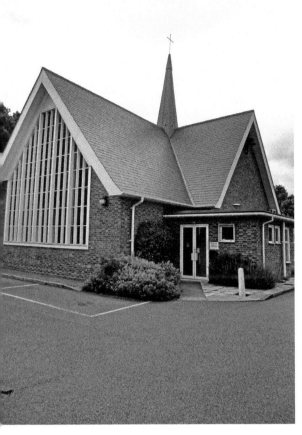

Church of the Good Shepherd, Pyrford.

Entrance board of the Church of the Good Shepherd.

6. Chapel Corner

In the early nineteenth century a small strict Baptist group decided that a permanent place of worship was needed. Some land was bought on the edge of Horsell Common and in 1815 a small chapel was built on the front of two existing cottages. The Trust Deed was written on vellum and signed by the trustees. Some of them were illiterate so they signed only with a cross. There was a small graveyard beside the chapel.

The congregation flourished over the years but little was done to the building and it started to deteriorate. In 1907 it was renovated and continued to be used by the Baptist congregation. In 1935 electricity replaced the original oil lamps. Over the following years the congregation declined as the elderly passed away and there were no newcomers.

In 1963 a member of a local Brethren group, Mr Sydney Fleet, bought the chapel from the trustees. He and his wife lived in the cottages behind the chapel, which became a place of worship for the Brethren group. When Mr Fleet died in 1986, the chapel was

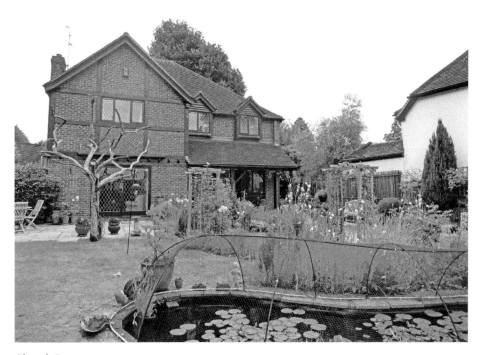

Chapel Corner.

Garden at Chapel Corner.

no longer used and deteriorated. Mr Fleet's son, Andrew, who had been a member of the congregation, decided that its long term of service should not be forgotten. In the late 1980s he demolished the chapel and the cottages and built a house on the site.

Over the years there had been several burials in the small graveyard and a number of gravestones had been erected. While there were no exhumations, a careful record was kept of the names of the dead and the bodies remained in situ. However, permission had to be obtained from the Home Office to remove the gravestones. When this was done, the graveyard became an attractive garden. Andrew named his new house, appropriately, Chapel Corner and he and his wife, Valerie, continue to live in it.

So that the original chapel should not be forgotten, a stained-glass representation of the building was made. This was inserted into the front door of Chapel Corner as a permanent reminder of the original place of worship.

7. Woking Station

In October 1834 work began on a new railway line to run from London to Southampton. Four years later the line had been completed as far as 'Woking Common' and on Saturday 12 May 1838 a group of invited guests travelled on the new railway line. The main entrance of the two-storey station building was built on the southern side of the railway and the two platforms were connected by a footbridge. There was a booking office, a general waiting room, a ladies' waiting room, toilets and even a stable block for the horses. The latter was necessary for shunting the carriages. A large bell had pride of place on top of the building – before each train departed, this was rung for five minutes.

Woking Council planned to build shops and houses on the southern side of the railway facing the station's main entrance. However, George Raistrick, a wealthy lawyer who owned much of the land, refused to sell it for development. Consequently, the council had to change its plans and erect the buildings on the northern side. Today commuters use the now completed railway line to travel from Woking to London.

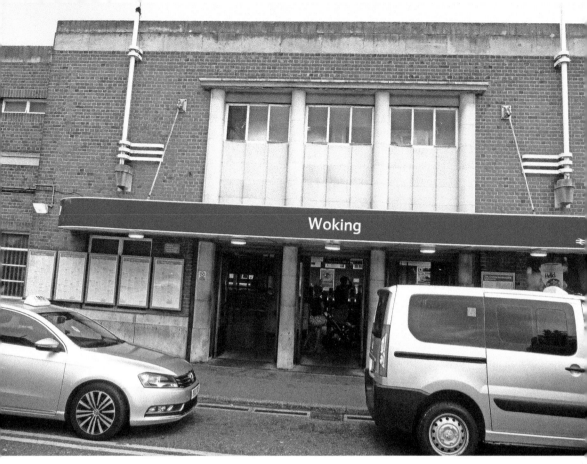

Above: Oriental Road entrance to Woking station.

Right: Town entrance to Woking station.

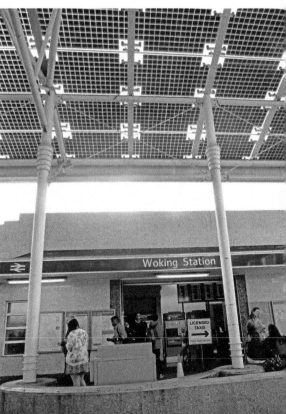

By the end of the twentieth century new businesses were flourishing in Woking, so employees were now also travelling to Woking for their work. However, the main entrance to the station remained on the southern side. It was not until the twenty-first century that the council decided to rectify this. The station was redesigned, the booking offices were upgraded, self-service ticket machines were installed in both station entrances, and a huge glass canopy was erected from the northern entrance over the road to Albion House on the opposite side.

Railway staff were reduced as ticket barriers were erected. With five platforms now in use, a lift was built to ferry passengers with luggage from one platform to another. Outside the southern entrance, taxis ply their trade and the coach to Heathrow hovers nearby.

8. The Sovereigns

With the building of the railway in the mid-nineteenth century, there was an increase of traffic in Woking. Mail coaches trundled through and somewhere was needed for both travellers and horses to rest before continuing their journeys. In 1840 the Railway Hotel was built in Guildford Road near the railway station. Stabling was provided for the horses. A bar was available for passengers to enjoy a drink while a trough on the green outside enabled horses to be refreshed. Food and accommodation was also available.

The Sovereigns.

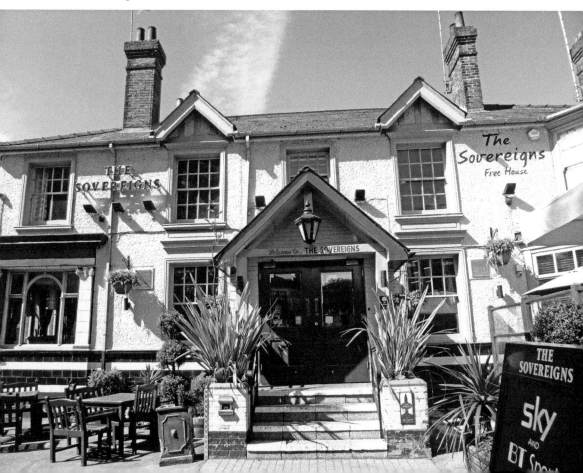

Eventually, Woking Common station was no longer the terminus as the railway line was extended. 'Common' was dropped from the name and it became 'Woking' only – a name it still bears. The town grew to embrace the growing number of commuters. The Railway Hotel was no longer needed so the building was enlarged and renovated. Over the years it has had several owners but currently it is owned by the Ember group and no longer provides accommodation. The new name is The Sovereigns. It continues to provide a variety of drinks and an extensive menu for visitors who are no longer regular railway travellers! The Sunday roast is popular with a variety of guests every week.

9. St John's Church

The soil in the Woking area consists of clay and sand. These deposits were ideal for making bricks and in the eighteenth century brickyards and a wharf were established. When, in 1788, work started on the Basingstoke Canal, these bricks were used to build the locks and bridges. The bricks were used locally and also further afield. As the brickworks grew and more workers flooded into the area, houses were built to accommodate them. The village was given the name of Kiln Bridge.

There was no church in the area and, as the population grew, it was decided to build a 'chapel of ease' (a chapel of ease is a small church built within a parish for the convenience of those who find it difficult to attend the parish church) connected to St Peter's Church. It was designed by Sir George Gilbert Scott and dedicated to St John the Baptist. The first service was held in 1842. In 1883 it became a parish in its own right within the diocese of Winchester. The name of the village was changed from Kiln Bridge to St John's, a name it still bears. In 1927 when the diocese of Guildford was created, it became part of that diocese.

Today, St John's Church has a flourishing congregation with regular Sunday services and a variety of activities are held during the week.

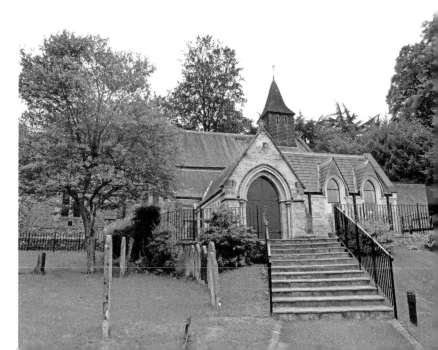

St John's Church.

10. Trinity Methodist Church

Alwyne House was built at the junction of Brewery Road and Chobham Road in the late 1850s. The Spencer Compton family lived in it until 1927 when they sold it to another family. It continued as a family home until the 1960s when it was demolished.

It was not until several years later that the site was again occupied. The Methodists had first worshipped in Woking in 1863 and over the years they occupied several venues. In the middle of the twentieth century it was decided that a permanent home was necessary for the growing congregation. The land on which Alwyne House had stood was purchased and the imposing Trinity Methodist Church was built. As well as the area for worship, there were a number of other rooms that are used for activities during the week. A kitchen and an area for refreshments were also provided and a flourishing congregation continues to worship there. In 2017 the church was full when the Women's World Day of Prayer was held there.

The name of Alwyne House was not forgotten. When some flats were built next to the church, they were given the name Alwyne Court.

Trinity Methodist Church.

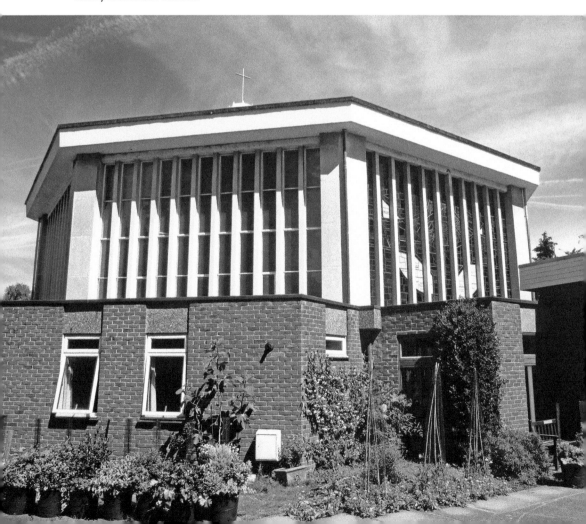

11. The Crematorium

In 1873 a 'cremation apparatus' was exhibited at the Vienna exposition. One of the visitors was Sir Henry Thomson, Queen Victoria's surgeon, who was very impressed with what he saw. He knew that burial space in our small island was rapidly running out and felt that cremation 'was becoming a necessary sanitary precaution against the propogation of disease'.

On 13 January 1874 Sir Henry founded the Cremation Society of Great Britain in his London home. There was still a great deal of land for sale in the Woking area. The Necropolis Company had only used a fraction of their purchase for the cemetery. In 1878 Sir Henry, with the aid of donations, bought an acre of land in St John's village. Professor Gorini from Italy was invited to come to England to supervise the first erection in the country of an experimental crematorium. To make sure the apparatus worked successfully it was decided that animals should be used to test it.

On 17 March 1879, the successful cremation of a horse took place at St John's Crematorium. There was still strong national and local opposition to the idea, particularly from the vicars of St Peter's and St John's. It was not until February 1884 that cremation was finally legalised in England.

The first human cremation at St John's took place a year later on 26 March 1885 and lasted an hour. Seventy-one-year-old Mrs Pickersgill of Clarence Gate, London, had been

Woking Crematorium.

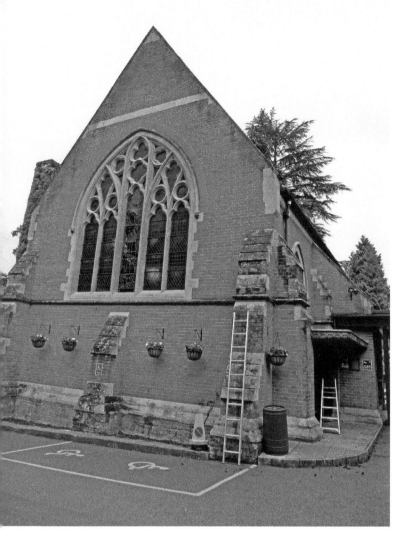

Woking Crematorium.

a member of the Cremation Society and, in her will, she had stipulated that her body was to be cremated. Other cremations soon followed and by the end of the nineteenth century around 2,000 had been recorded. More land was bought and a chapel, waiting room and other facilities were built. Some of this is now used for a small car park but in the twenty-first century, the crematorium is kept very busy and more parking space is required. Occasionally funerals are delayed while mourners try to park!

12. Lion House

In 1 June 1860, Prince Albert lay the foundation stone of the Royal Dramatic College for 'decaying (retired) actors and actresses'. The college was built and the first residents entered in 1862 but it was not until 1865 that the college was officially opened. Unfortunately it was not a success. The money ran out and eventually in 1883 it was sold to Dr Gottlib Withelm Leitner, who founded the Oriental Institute.

When Dr Leitner died in 1899, the institute was closed. In the early part of the twentieth century the site was taken over by the Martynside Aircraft factory, who used it until 1923 when the factory closed. In 1926, the site was bought by James Walker & Co. James Walker had trained as an engineer and realised that an engineering plant needed effective packing to protect its products. He started to develop strong packaging, which was patented in 1888. He used 'Lion' as his commercial brand name and the first Walker Lion trademark for his packaging was used in March 1889.

In the twentieth century the company continued to expand and in 1911 James Walker & Co. became a limited company. James Walker died in 1913 but the company continued under the chairmanship of George Cook. During the First World War it was kept very busy and following its success, it advertised itself as 'Lion, the King of Packings'. When it needed yet another new site, the empty factory in Oriental Road was ideal.

The Lion Works continued to function on the site until 1993, when it closed. The buildings were demolished and the site is now the Lion Retail Park in memory of the Lion Works, which had provided jobs for Woking residents for so many years. The retail park consists of a variety of shops including ASDA and Argos and has a large car park, on the corner of which is Costa.

James Walker & Co. Ltd continues to flourish and its headquarters are now in Lion House beside the retail park. It has its own car park.

Right: Retail park.

Below: Lion House.

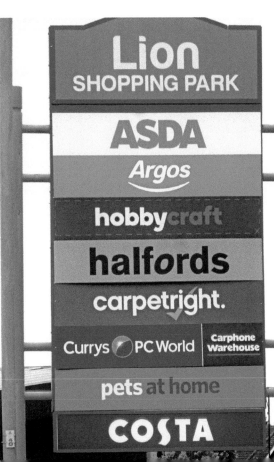

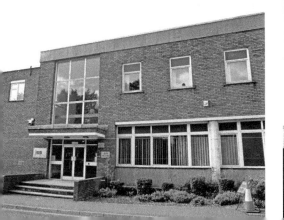

13. The Shah Jehan Mosque

In 1883 Dr Gottlib Wilhelm Leitner bought the defunct Royal Dramatic College that had lasted such a short time. The large Victorian building was perfect for his purpose. He renamed it the Oriental Institute and this gave the name to Oriental Road. Asian students came to study and in 1889 Leitner built a mosque in the grounds so that his Moslem students could worship there; it was England's first mosque. The ruler of Bhopal State in India, the Begum Shah Jehan, donated a large sum for its building as did many other Indian Moslems. The mosque was named Shah Jehan after its generous benefactor.

The architect was Mr W. I. Chambers. He designed it using illustrations from the Oriental Art Arabe and other oriental drawings. The building was created in Bath and Bargate stone. Four minarets stand around the blue and gold dome, which is surmounted by a gilt crescent. A number of steps lead up to its entrance. The mosaic pavement in front of the building surrounds a reservoir for worshippers to wash before entering the holy building.

Dr Leitner died in 1899 and there was no one to carry on his work. The books and artefacts were sold and the institute and the mosque were closed. In 1912 the latter was reopened. A Moslem missionary, Khwaja Kamal ud Dion, visited Woking and discovered the 'dirty neglected building'. He restored it and it was in use once again. New buildings were erected adjacent to it.

After the Second World War and the creation of Pakistan in 1948, many Pakistanis left their homeland and came to Britain. Because of the mosque, a great number of them settled

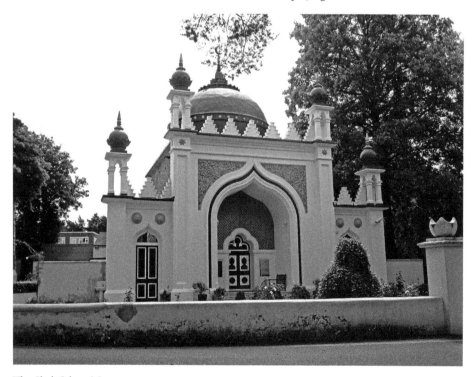

The Shah Jehan Mosque.

Old photo of the mosque.

in Maybury near their place of worship. Every day Pakistani children attend classes in the surrounding buildings to learn Arabic and read the Koran. Every Friday worshippers flock to the mosque for Friday prayers.

Visitors are welcome to visit this beautiful building on the regularly held open days. Recently renovated and restored to its former glory, it is now a Grade II-listed building.

14. The Church of the Holy Cross

The Church of the Holy Cross is set back from the road in Sandy Lane, Maybury. It was originally the chapel of the nearby convent run by nuns of the Anglican Order of St Peter. This order had been founded in Kilburn in 1861 by Benjamin and Rosamira Lancaster for the 'Nursing of ladies in bad health and narrow circumstance'.

In 1883 the sisters were given some land in Woking for 'use as they saw fit'. Benjamin Lancaster provided money for the building of a memorial home for 'incurables'. The foundation stone was laid in 1883 and the home was opened in 1885 with forty nuns caring for sixty patients. In 1898 another foundation stone was laid nearby for a chapel. The famous architect John Loughborough Pearson was chosen to design it. When completed, it was considered to be his finest work. The foundation stone can still be seen on

Pulpit in the Church of the Holy Cross.

the base of one of the pillars. The chapel was dedicated to St Peter in memory of Susan, the first Mother Superior of the order.

There are two other memorials relating to the chapel's earlier days. On the south wall, brought from Kilburn, its original home, is a brass commemorating the order's founder, Benjamin Lancaster. The third commemorative brass, also from Kilburn, is in memory of the Revd W. H. Cleaver, who had been the first warden of the community and had served for forty-four years.

At the top of the steps leading to the crypt is a hand-operated lift originally used to carry wheelchair patients. The organ was installed in 1900. In 1984 the chapel became a Grade II-listed building.

In the 1990s there were fewer nuns and in 1996 the Roman Catholic Society of St Pius X acquired the chapel and renamed it the Church of the Holy Cross. A new altar and baptismal font, donated from other churches, were installed and several statues were placed in strategic positions around the church. Today masses are regularly attended by a loyal congregation.

The Convent of St Peter closed in 2004 and the building was converted into a luxurious apartment building.

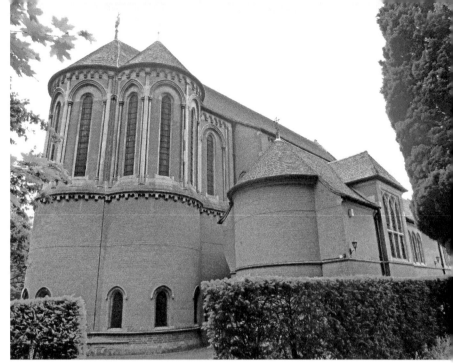

Church of the
Holy Cross.

15. Christ Church

As there was no town church in the 1870s, services were held in a room above a shop in
Chertsey Road. At first, the room was large enough to accommodate the worshippers but
they eventually outgrew it and needed more space.

In 1877 a building was erected on the site planned for the church; this became known as
the 'Iron Room' and could seat 400 worshippers. As the congregation continued to grow,
a new church became a necessity and it was decided that money must be found to build
one next to the Iron Room. Donations were received but it was not until 1887 that enough
money had been raised to start building. The foundation stone of Christ Church was laid by
the Duchess of Albany, a daughter-in-law of Queen Victoria. A thousand people attended
the service led by the Bishop of Winchester, in whose diocese Woking lay.

The building work continued and the first service was held on New Year's Day 1889,
although the church was still being built. The church was finally completed in 1893 and the
Bishop of Winchester led the consecration service on 14 June. The church was separated
from the parish of St Peter's by the railway line so the diocese decreed that Christ Church
should become a separate parish; this was confirmed on 29 August 1893. In October Christ
Church's first vicar was installed.

Since its origins the building has been adapted to accommodate the growing congregation.
At the end of the twentieth century the pews were removed and replaced by chairs. In the
twenty-first century Christ Church serves not only its regular congregation but also the
wider community. Lunchtime concerts are often held in the church and the west end is now
a popular coffee shop serving breakfasts and light lunches. A door on the north side opens
into the Origin bookshop, which stocks cards and a variety of books. Above the church are
several rooms that are used for church activities as well as by other community groups. At
Christmastime one of the rooms is used as a Christmas charity card shop.

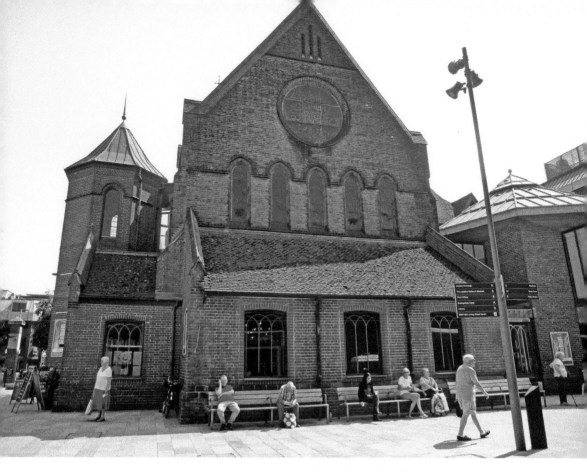

Above: Christ Church.

Left: Main entrance to Christ Church.

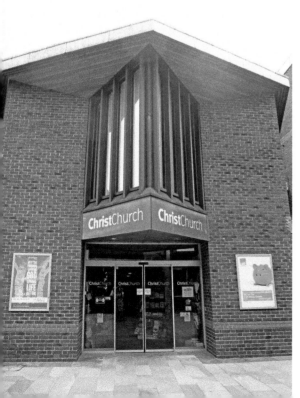

16. St Paul's Church

The population of Maybury, originally part of Woking Common, also grew during the latter part of the nineteenth century. The current vicar of Christ Church, William Hamilton, decided that the time was right for a chapel of ease, connected to Christ Church, to be built in Maybury. The land was still owned by the London Necropolis and National Mausoleum Company. In 1894 a contract was eventually signed between the Mausoleum Company and the Trustees, Patrons of the Patronage of Christ Church. The trustees paid £290 for '2,340 square yards or thereabouts … to be used … for such Mission and other church purposes including public worship'.

The church was designed by Ewan Christian and a local builder, Richard James Harris, was employed to build it. Much of the cost was generously born by William Hamilton himself. Because the area was wooded, a number of trees were felled to clear a space for the church. The foundation stone of St Paul's Church was laid on 30 October 1884 by Lord Middleton, the president of the National Protestant Union. The building work then continued. The nave consisted of red bricks but the external bricks were brown.

The building was completed in 1885 and on 28 November of that year, the Bishop of Winchester, in whose parish St Paul's lay, took the consecration service. It was poorly attended and only eight people sat on the wooden chairs that had been provided for a much larger congregation. These were later replaced by pews. The only stained-glass window was installed in 1896. This had been presented by John Sherrin, a member of the congregation, in memory of his wife, Ellen Mary. Because the church was still surrounded by trees, it became known affectionately as 'The Church in the Trees'.

St Paul's Church.

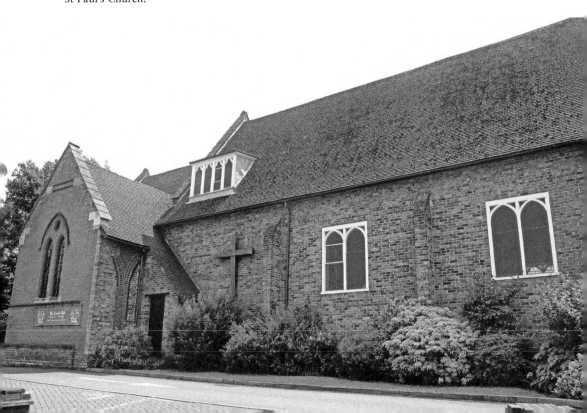

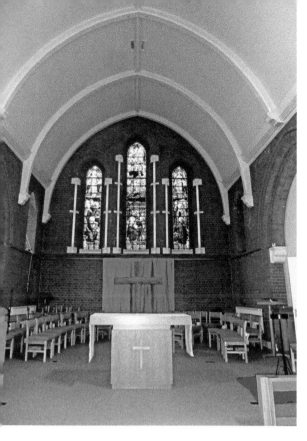

Inside St Paul's Church.

During the twentieth century extensions were added and in 1956 a new church hall was built on the south side of the church. In 1959 St Paul's became a parish in the new diocese of Guildford. In the twenty-first century it continues to serve its growing congregation and the wider community.

17. Salvation Army Community Church

There has been a Salvation Army presence in Woking since the late nineteenth century. In 1887 a Salvation Army officer brought some copies of the Salvation Army magazine, the *War Cry*, to the growing town. He was soon followed by others and within a few weeks a 'Corps' of new members had been created. They met in rooms above a shop at the junction of Church Road and Chobham Road.

In 1897 the corps was officially opened and the first 'soldier' was enrolled – she was a 'sister'. More followed – both 'brothers' and 'sisters' – and meetings were regularly held in local hired halls and also in the open air. The corps soon outgrew its premises and needed a permanent base.

A suitable site was found on the corner of Church Street and Clarence Avenue and building commenced. In 1897 the new Salvation Army Hall was officially opened. This continued to be used until the twentieth century when Woking Borough Council started redevelopment of the town. The hall was demolished and it was some time before new premises were found. Meanwhile, the corps was able to use the facilities offered by other Woking churches.

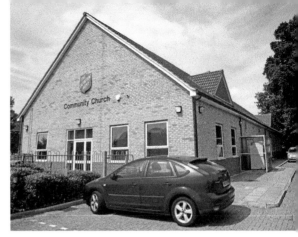

The Community Church.

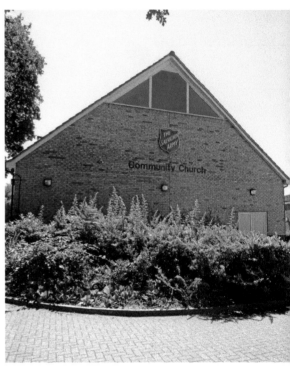

In the 1970s building was started on a new hall in Walton Road. This was completed in 1972 and on 15 April the corps marched through the town to Walton Road for the opening ceremony. These premises continued to be used until the twenty-first century and in 2005 there was more redevelopment of the area. The hall was demolished and replaced by flats.

A new site was eventually found at the junction of Bullbeggars Lane and Sythwood in Horsell. Planning permission was obtained and the building started using modern technology. There was a rainwater-harvesting plant, a monodraught ventilation system and solar panels.

The new Salvation Army Community Hall is used by the community as well as the corps. There is a large worship area, numerous rooms and the foyer boasts a popular café. The official opening of the new building was on 19 January 2008. It was attended by a large crowd and the community church continues to be in constant use.

18. Sands

Bleak House was built on Horsell Common in the late nineteenth century. Its name had nothing to do with Charles Dickens' book of the same name. When it was first built, the land around it was very desolate and 'bleak' so 'Bleak House' was considered an appropriate name.

The area changed considerably over the following years. Chertsey Road was built and when the M25 was opened in the middle of the twentieth century, the amount of traffic on Chertsey Road greatly increased. Bleak House, owned by the brewery, became a popular stopping place for travellers heading to the motorway. Local residents also enjoyed its varied menu and popular Sunday roast.

Then, in 2004, the brewery sold the inn and the new landlords changed its name to Sands – a reminder of the sandpits on Horsell Common. As well as restaurant and bar, Sands offers accommodation with several en-suite rooms, as well as a luxury suite and free Wi-Fi. A continental breakfast is included. The restaurant continues to offer a varied menu to suit all tastes and the Sunday roast continues to be popular. If the weather is suitable, visitors can enjoy their food in the garden.

Sands.

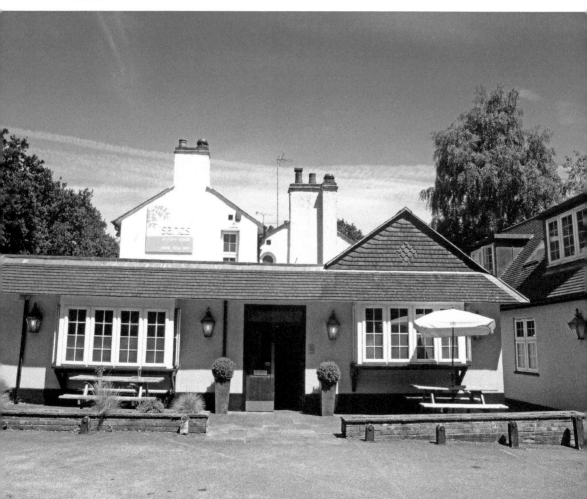

Twentieth Century

In 1895 Woking became an urban district council. It set up its offices above Ashby's Bank in the Broadway. Sadly, in 1899 the offices were destroyed by fire and the council took up temporary accommodation in Commercial Road. It was not until 1905 that a new purpose-built Council Office building was erected. In 1930 Woking was presented with its first coat of arms, depicting links with Woking's past history. It contains the Latin words '*Fide et Diligentia*' ('Faithful and Diligent').

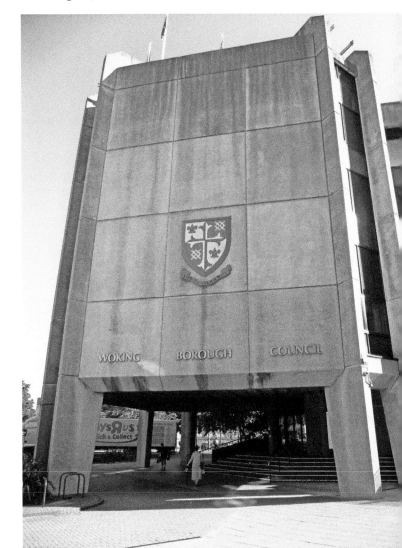

Council Offices.

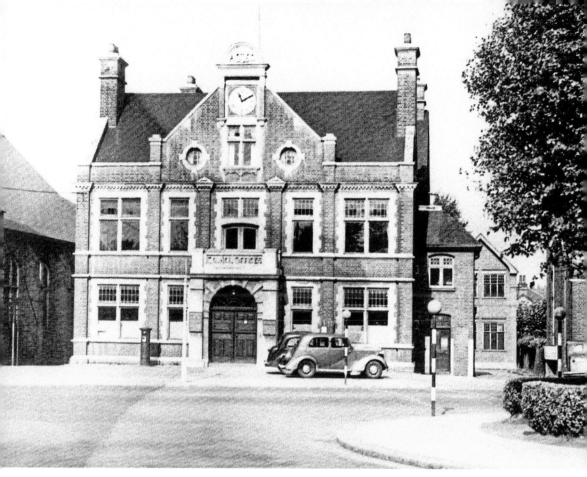

Council Offices in Commercial Road. (Courtesy of David Rose)

The town of Woking continued to grow and in 1933 the council applied for a charter of incorporation to become a borough. Unfortunately the application was rejected. A second petition in the 1950s was also refused. It was not until 1974 that the Queen granted Woking permission to become a Borough Council with the right to elect its own mayor.

Woking's first mayor was Christopher Meredyth Mitchell, who was elected unanimously by the council members. James Walker & Co., a local firm, presented the new mayor with his gold badge of office. A company, of which he was a director, funded the mayoral robes; these were of scarlet, trimmed with fur and lined with white silk. The headgear was a cocked hat. The robes are worn on all ceremonial and civic events including council meetings.

During the 1980s Woking was being redeveloped and the Council Offices in Commercial Road were demolished. A new Council Office building was erected in Gloucester Walk opposite the canal. Woking's coat of arms was emblazoned on the side and over it flies St George's flag. On 20 April 1983 this was officially opened by the Duke of Gloucester.

The building incorporates a number of rooms to deal with council business as well as the impressive Council Chamber with its reminder of Woking's past. The stained-glass window behind the Mayor's Chair contains wavy lines to represent the railway; the brown below this indicates the urban area while the blue section is the canal. Vapour trails across the blue at the top of the window are a reminder of the closeness of Heathrow Airport.

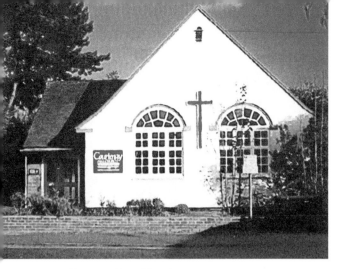
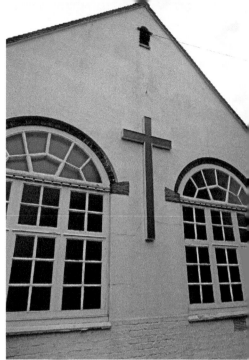

Courtney Free Church.

2c. Courtney Free Church

As there was the need for a place of worship in the Courtney Road area, a hall was eventually found at the rear of a house, which had originally been used as a laundry. The Courtney Road Fellowship rented the hall in 1905 and adapted it for their purposes; it seated thirty worshippers. The following year a Sunday school was started followed by a Women's Meeting.

By 1908 more space was needed and the ground floor of a nearby empty builders' workshop was taken over. A fourteen-year lease was obtained and alterations to accommodate a congregation of 140 were made. In 1922 the lease ran out, the building was sold and, for a while, it seemed that the group could no longer function.

However, a wealthy benefactor became interested; he gifted some land in Courtney Road to the trustees and he also paid £600 for a new building to be erected on the site. This was done within seven weeks and a service of dedication was held on 4 October 1922. Another room was added at the rear in 1923 and in 1928 two more rooms were added.

In 1944 the Fellowship changed its name to Courtney Free Church – a name by which it is still known. The buildings in Courtney Road continued to be used until the 1960s when Woking Borough Council scheduled the area for redevelopment and new premises were again needed. These were eventually found at the end of Walton Road.

At the beginning of the twentieth century St Paul's Church in Oriental Road had no church hall so a 'Mission Hall' had been erected in 1906 at the end of Walton Road. When a hall was eventually built onto the existing church, the hall was no longer needed. In 1967 the area was acquired by Courtney Free Church. The hall was renovated, a heated pool for baptism was installed and groups catering for all ages were set up. Today the church is both a place of worship and also a meeting venue for local groups in the community.

21. St Mary of Bethany

In 1896 William Hamilton, the wealthy vicar of Christ Church, purchased two plots of land in Mount Hermon Road. The population in the area was growing and a church was needed. In 1905 William Hamilton left Woking and moved to Norfolk. As a generous parting gift to the parish, he gave enough money for the building of a church on the land he had bought. The foundation stone of St Mary of Bethany was laid in 1906 and the church was consecrated as a chapel of ease to Christ Church.

The architect was W. D. Carol, who was famous for his Arts and Crafts design, which he incorporated into the building of the new church. The large windows made the interior light and airy and bright colours were used for the decoration. The reredos, the wooden screen behind the altar, was carved by the famous sculptor Nathaniel Hitch. The colourful stained-glass window on the east wall was created by Heaton, Butler and Byrne. Choir stalls on the north and south sides of the chancel were installed.

In 1907 St Mary of Bethany was one of the first buildings in Woking to have electricity installed. By the 1920s the population in the area had grown to 3,000 and in 1923 the diocese of Winchester decreed that St Mary of Bethany should become a parish in its own right.

In 1960 a hall, dedicated to its benefactor, William Hamilton, was built on the south side of the church. In 1974 the porch was demolished and a new extension linked Hamilton Hall to the new main entrance on the west side. In 1984 St Mary of Bethany became a Grade II-listed building.

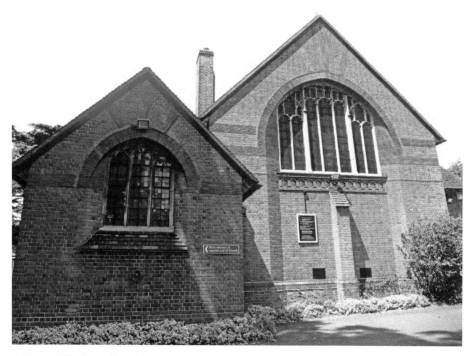

St Mary of Bethany Church.

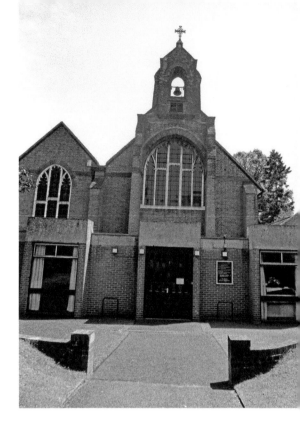

Main door of St Mary of Bethany.

In the 1990s a major redesign of the interior of the church was undertaken. Breaking with tradition, the seating was turned to face the north wall, below which a dais had been erected. Like its sister churches, St Mary of Bethany has a growing congregation with regular services and activities cater for all sections of the community.

22. Woking Homes

Woking Homes is a residential home for senior citizens situated in Oriental Road. Its origins were in London in the late nineteenth century and it catered, not for the elderly, but for the young.

The Revd Canon Allen Edwards of All Saints' Church in Lambeth was also the railway chaplain. He became very concerned about the number of homeless railway orphans. In 1885 he bought a house in Jeffreys Road, Clapham, and in 1886 the first 'fatherless girls' moved into their new home. The new London Orphanage and South Western Servants' Orphanage was set up as a charity with a board of management. Railway workers were happy to contribute to its upkeep. The number of girls soon reached fifty and a second house was bought, followed by a third in 1895 for 'fatherless boys'.

In 1907 several acres of land were purchased in Oriental Road near Woking's railway station and the foundation stone was laid. By 1909 the new building, which could accommodate 150 children, was completed and the first orphans moved in.

The boys and girls were in separate units. After they had done their chores, they went to local schools. On Sundays they attended St Paul's Church, which was in the same road. In the 1920s the name was changed to the Southern Railwaymen's Home for Children.

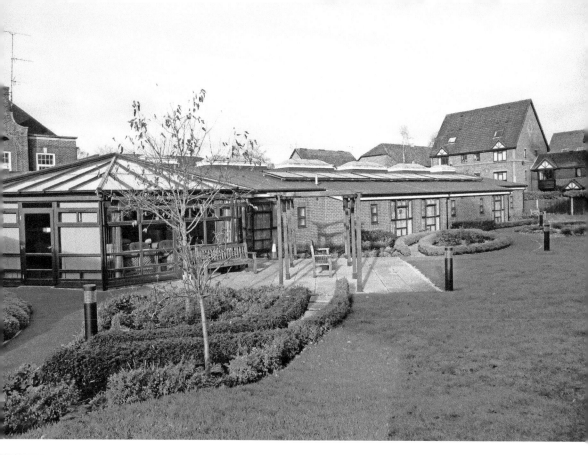

Above: Woking Homes.

Left: Entrance to Woking Homes.

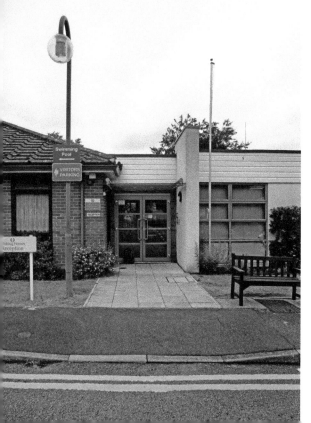

When the children left the home at the age of fourteen, many of the girls went into service while the boys worked on the railway.

In the middle of the twentieth century the number of orphans had declined and the buildings were adapted for the use of fifty senior citizens. The last orphan left in 1989. In 1982 the name was changed to Woking Homes. In 1985 the centenary of the founding of the original orphanage was celebrated with a commemoration service in St Paul's Church. During the 1990s all the rooms became en-suite, a conservatory was added on to the lounge, and a heated indoor swimming pool was built. This was officially opened in August 2000 by the railway artist David Shepherd. Building work continued into the twenty-first century.

23. All Saints' Church, Woodham

The population was also growing in the Woodham area and a new church was needed. In 1883 the foundation stone of All Saints' Church was laid in Woodham Lane. It was partly completed the following year and services were held in the partially built building. In 1902, although it was not completed, the diocese created the parish of All Saints. However, it was not until five years later in 1907 that the church was finally completed. Although Anglican, the church follows the Catholic tradition and still holds a daily mass.

The parish hall behind the church was renovated in the twenty-first century and the church provides a variety of services and activities through the year for its congregation and the community. There are exhibitions, lunches, fundraising events and children's activities.

All Saints' Church, Woodham.

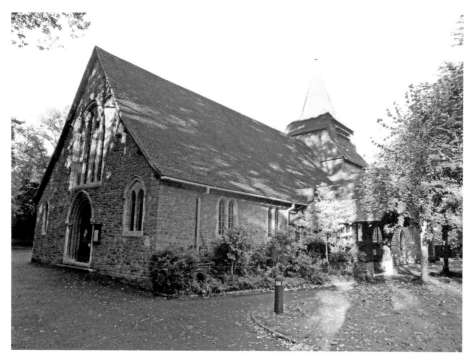

All Saints' Church, Woodham.

In the 1950s after the Second World War, the Sheerwater estate was created in the parish of All Saints' and a thousand new houses were built. A daughter church, St Michaels,' was founded. As there was no Methodist church in the area, it became an ecumenical church sharing its premises with Methodists.

It is no longer a daughter church of All Saints' and now has a priest-in-charge. She was appointed in 2016.

24. Horsell Parish Hall

Horsell Parish Hall, situated in the High Street, was built in 1907. Today it is run by a group of trustees drawn from the local community. It is in constant demand as a rehearsal venue and as a place for local societies and clubs to hold their meetings. Parties and dances are also held there. Until the 1970s, it also played host to a number of dramatic productions.

Before the First World War the local curate staged a production of Shakespeare's *A Midsummer Night's Dream* using local villagers for his cast. Then in the 1920s Horsell Amateur Dramatic Society (HADS) was born. The society's first performance of *One Flat* in 1921 was private. It was so successful that it was followed by the society's first public performance of *The Man from Toronto* by Douglas Murray. This was held, of course, in the Parish Hall and followed by many others over the coming years.

At first these were very formal occasions and the audience always wore evening dress. Saturday nights were particularly popular when bouquets were presented to the cast and glamourous 'after show' parties were held in the basement of the Parish Hall.

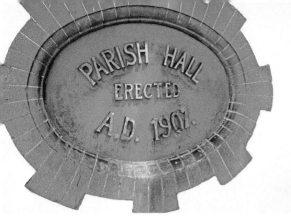

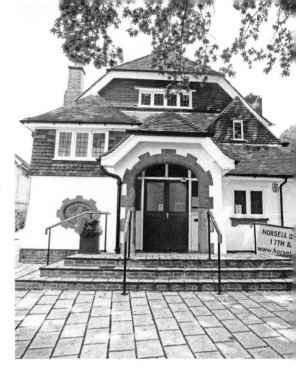

Above: Plaque on Horsell Parish Hall.

Right: Horsell Parish Hall.

No major productions were held during the Second World War, although the society took part in a number of national drama festivals. The first production after the war was *The Barretts of Wimpole Street*, written in 1930 by Rudolf Besier, which was a great success and HADS was delighted to be performing again in the parish hall. The society continued to produce an annual play until the hall no longer had a licence for public performance.

The reason for this was the Rhoda McGaw Theatre in the town centre, which had opened its doors for the first time in 1976. In 1979 HADS's first performance at the new theatre was *Absurd Person Singular* by Alan Aykbourne. It continues to use the same venue annually. However, the society, with others, still uses the parish hall for auditions and rehearsals. In the twenty-first century a new car park was added at the back of the hall.

25. The Pool in the Park

In the early twentieth century swimming was becoming popular but Woking had no swimming pool. Then in 1910 it was decided that water from the Hoe Stream could be used to fill a primitive swimming pool. The site was not ideal as it was near a refuse dump but Woking residents swam in it for over twenty years. Eventually it was decided that the area was not healthy. Open-air swimming pools in the lido style were now fashionable and in 1935 one was opened in Woking further away from the refuse dump.

This continued to be used for much of the twentieth century but as the rest of Woking was being redeveloped, it was felt that the swimming pool and leisure facilities should keep up with the times. In 1976 Freedom Leisure, a large charitable trust, was used to create a leisure centre in Woking Park. At the end of the 1980s the trust produced plans for a new swimming pool and leisure centre in Woking Park. A competition was held to find a

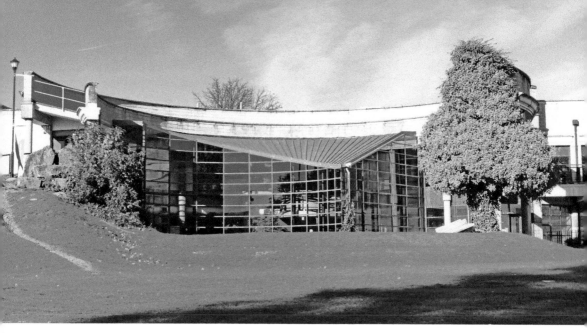

Pool in the Park.

suitable name for the swimming pool. The competition was won by a local primary school girl, who produced the delightful alliterative title The Pool in the Park.

The first phase of the new swimming pool was completed in November 1989. The new pool, providing facilities for both adults and children, was enclosed in glass and the water temperature was a welcome change from the chill of the previous lido. Work continued to enhance the facilities. In 1992 the second phase was completed. A large lagoon with two flumes and a lazy river ride was opened to great acclaim. Later a 25-metre competition pool was added.

Today the Pool in the Park provides a variety of classes and competitions and lifeguards are always nearby. There are Holiday Swimming Crash Courses, Swim School for both adults and children and Aqua Fitness classes as well as opportunities for parties and clubs to participate. Visitors can take out a monthly or annual membership and a café is available where visitors can relax after a swim or a class.

26. The Police Station

During the early part of the twentieth century a number of primary schools were established in Woking. In 1910 some land was bought in Guildford Road on which to build the first secondary school; this was for boys – secondary education for girls came later. The school was completed in 1914 and 150 candidates applied for the post of headmaster. Joshua Holden from Yorkshire was the successful applicant and the Boys' Secondary School opened with its first intake of fifty boys.

Under his leadership the school flourished. In 1918 one of the masters, Reginald Church, formed a drama group that performed Shakespeare's *Twelfth Night*. The production was so successful that a tradition was born and a play was performed every year to large audiences. Mr Holden retired in 1932 by which time the numbers on the roll had risen to 331.

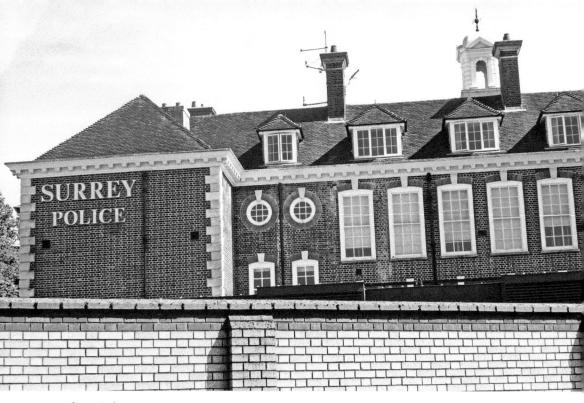

Above: Police station.

Below left: Surrey Police.

Below right: Cupola on top of the police station.

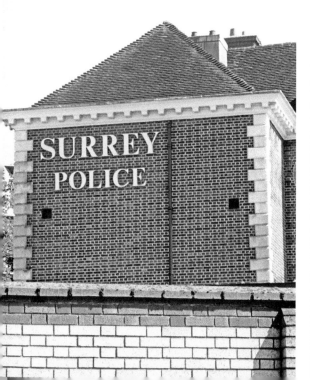 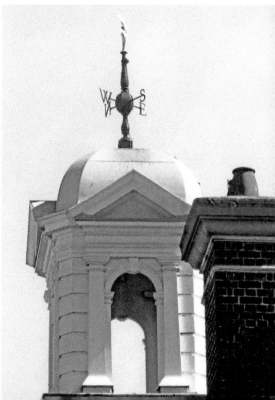

The school continued to grow and by 1949 it had become the Boys' Grammar School. Its annual production attracted distinguished visitors. One of these was the Norwegian ambassador, who was so impressed that he invited the group to perform in Norway. This they did to great acclaim.

In 1976 the curtain came down on the fifty-fifth and final performance, which was *A Man's House* by John Drinkwater. Terry Hands, an old boy who had starred in many productions, was in the audience. At the time he was the assistant director of the Royal Shakespeare Company. There would be no more plays in the school hall as the life of the Boys' Grammar School was drawing to a close. It finally shut its doors in 1982.

The building remained empty until 1990, when it was taken over by the police and adapted for their purposes. On 18 October 1990 the Duke of Gloucester opened the new police station with its surrounding court complex.

In 2005 a review of the facilities of the building and its surroundings took place and this still continues as the old buildings need more work to bring them in line with the twenty-first century.

27. The Library

There has been a library in Woking for many years, although, with Woking frequently 'regenerating' itself, it has had to move on several occasions. When the council decided that the town needed a public library, appropriate premises were sought. These were eventually found in Percy Street. A building that had originally been a Roman Catholic church was acquired and in the 1920s Woking's first Public Library opened its doors.

With television still in the future, Woking residents flocked to borrow books. No longer did they need to buy them. The library was to become a permanent fixture, although the venue was to change several times. In 1934 the Methodists moved from their building in Chapel Street. By now, the library had outgrown Percy Street and needed new premises. The empty Methodist chapel was ideal and was soon converted into a library to hold an increasing number of books.

This continued to be used until the latter part of the twentieth century when Woking was being redeveloped again. The 'chapel' was to be demolished and the library needed a new venue once again. This time a new modernised building to house the library was built in Commercial Road. Then, in the 1990s, there was more redevelopment. In 1992 the library was relocated to yet another new building in the town centre opposite the war memorial. It remained there into the twenty-first century.

Then, in 2012, it had its final move as it made way for one the many eating places that Woking now boasts. This was the prestigious Café Rouge, which opened in 2013. On this occasion the library did not have to move far; it was shifted back towards the canal behind the restaurant. The library, with its updated technology, is still used regularly by a variety of visitors. It now houses not only books, but also computers. Beginners can be introduced to the new technology, others can 'surf the net' or check their emails, and students can research and work at the many tables scattered around. Others who wish to relax can sit in armchairs and browse through the latest newspapers and magazines.

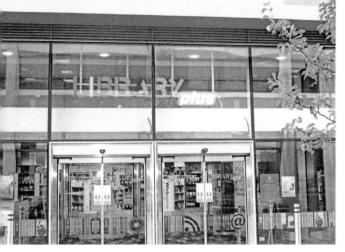

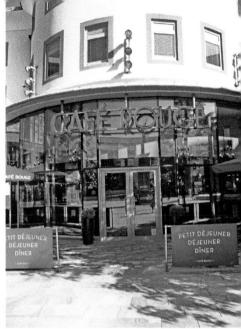

Above: Woking Library.

Right: Café Rouge.

28. Greenfield School

During the 1920s more schools for young children were opened in Woking. One of these was Denham House at the end of Constitution Hill. In 1922 this became a Notre Dame School and functioned until the 1930s when it changed hands. The new owners renamed it 'Greenfield School' – a name it still bears. The first headmistress of the 'new' school was Ruth Hicks. She was ably supported by her friend, Joyce Pearce, who had founded the Ockenden Venture.

In 1939 'Beechlands', a Victorian house in Brooklyn Road, came up for sale. Miss Hicks bought it and moved the school to its new premises, which are still used. Parents of present pupils remember attending the original building in Constitution Hill. Beechlands was adapted for use as a school but characteristics of the Victorian building were retained. There was spacious accommodation and light airy spaces in which the children could work.

Originally a school for girls only, Greenfield later embraced boys and continues to do so. The 'pre-prep' group takes pupils at the age of three and they continue in the school until the age of eleven when they go to secondary school. Many of them win scholarships to some of the excellent secondary schools in the area. The school continues to follow the high standard set by Miss Hicks, the first headmistress. It has been described as 'the best Junior School in Surrey' and the School Inspectorate recently rated it as 'excellent'. The curriculum is varied and the sports facilities rival those of local secondary schools. There is a cricket ground, swimming pool, athletics track and several other pitches.

The pupils are encouraged to develop their full potential and engage in extra-curricular activities. They learn to play a variety of musical instruments and can showcase their talents in concerts to audiences of families and friends. Public speaking competitions are popular and French came to life when pupils watched a stage play performed in French at King Edward's School in Witley. Pupils' creative writing is aided by walking on Horsell Common before they pen poems about their experiences. Greenfield School ably equips pupils for their future life.

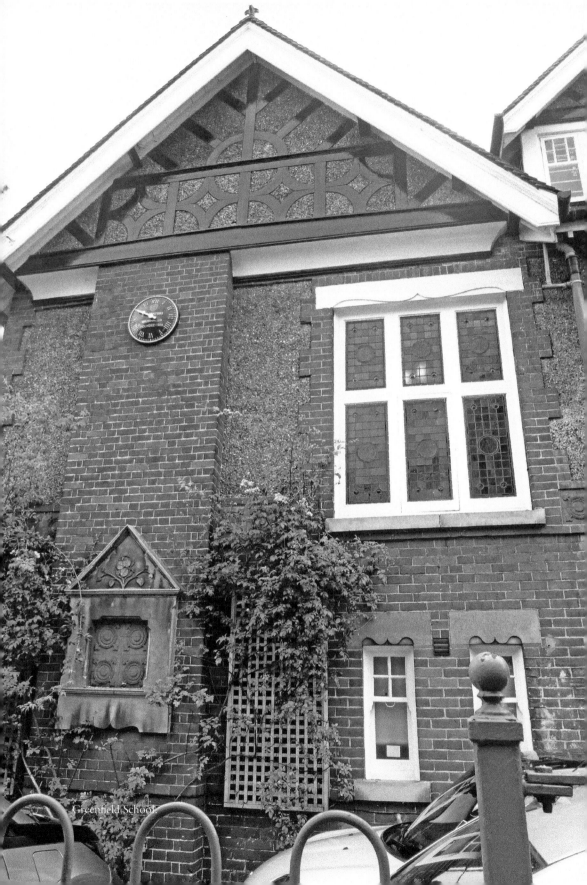

Greenfield School.

29. The Park School

When it was decided that girls as well as boys should have access to secondary education, no suitable building could be found to house them. Nevertheless, applications were invited for the post of headmistress. 160 were received and the final choice was Miss Katherine Maris. A graduate from Newham College, Cambridge, she had a first-class degree in science.

In September 1923 she took up her post in the school's 'temporary' buildings. These consisted of four huts, which had been used by the army during the First World War. They were linked by a number of covered pathways with the sides open to the elements. There was space near the huts for some tennis courts and a small 'Sixth Form Lawn' but there was no room for playing fields. On games afternoons the girls trudged to the other end of the town where there was a field with facilities for playing hockey in the winter and cricket in the summer.

In spite of the difficulties, the school developed into an excellent girls' grammar school, making good use of the limited facilities. One of the huts became a hall with a stage at one end for productions. On one side, wall bars indicated another use as a gymnasium. At lunchtime the hall became a canteen.

Park School.

During the Second World War an air-raid shelter was built for the girls to huddle in as the planes flew overhead. When, in 1946, Miss Maris retired, Miss Violet Hill replaced her; under her leadership the school continued to flourish, although the new headmistress considered that the accommodation problem was becoming 'desperate'. It was 'solved' by building more huts!

It was not until 1953 that building started on a new Girls' Grammar School on the corner of East Hill and the Old Woking Road. The new school was finally opened in 1958. The site of the original school was eventually taken over by the Park School. The huts were removed and a permanent purpose-built building was erected to accommodate boys and girls with learning difficulties. Like its predecessor on the site, it is an excellent school.

3c. The Broadway Building

The building on the corner of Chertsey Road and The Broadway has changed little since it was first built in the nineteenth century. Originally the junction was between Chertsey Road and Maybury Road but in 1923 the end of Maybury Road was renamed The Broadway, where many buses today start their journey. Much of the land on the north side of the station was, at this time, owned by the Necropolis Company and it was from them that George Rastrick bought the site. Tradition suggests that he was then tricked into selling it to a company who promptly sold it again at a vastly increased profit.

Eventually Asbyby's Bank was built on the site. The offices above the bank were used by Woking Urban District Council. Sadly, this part of the building was destroyed by fire in 1899 and the council moved to new premises in Commercial Road. The lower part of the building was undamaged and was later taken over by Barclays Bank. This later moved its premises to the town square opposite Christ Church. The original building still stands and was eventually taken over by the convenience store, Budgen's, which is still regularly used.

The Broadway Building.

31. St Dunstan's Church

At the end of the nineteenth century there was no church in Woking for the Roman Catholics. They had to travel to Send or Sutton Green to worship. In 1899 Father Allanson built an iron church in Percy Street and dedicated it to St Dunstan. It was used until the 1920s. In 1923 Father Plummer became the new parish priest. He was not impressed with the current building and decided that a new church in the Gothic style should be built.

A site was found in Heathside Crescent and the foundation stone was laid. The church was designed by Joseph Goldie and completed in 1925. The first mass was held in December of that year. The Catholic population grew and two other churches were built in the area. After the Second World War, Italians settled in Woking and masses in Italian as well as English were held on Sundays. In 1954 Father Plummer died and was buried in the grounds beside the church.

In 1958 St Dunstan's School was established and in 1973 a second school, St Francis, was opened in Shaftesbury Road. This was closed in 1993 and the pupils joined St Dunstan's. However, the site was retained for the building of a new church as Heathside Crescent was scheduled for redevelopment.

In 2003 the other Catholic Churches were closed and in 2006 work began on the new St Dunstan's Church at the corner of Shaftesbury Road and Pembroke Road. When the old church was demolished, the remains of Father Plummer were reinterred in the cemetery near St Edward the Confessor Chapel in Sutton Green.

The new church was completed in 2008 and dedicated in October by the Bishop of Arundel and Brighton. There is a mass every weekday at 10 o'clock and five Sunday masses are held. Attached to the church is a large hall that continues to be in regular use by various groups both within the church and in the community. During Lent, Lent lunches are held every Friday. The other churches in the area always support these.

St Dunstan's Church.

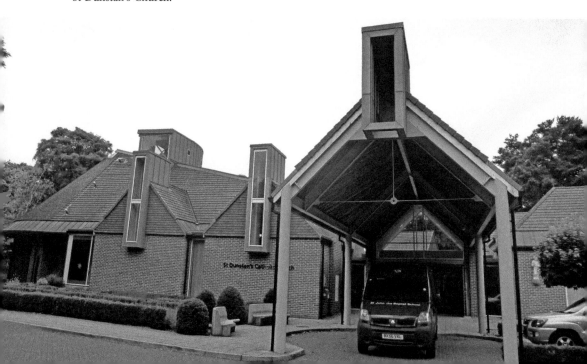

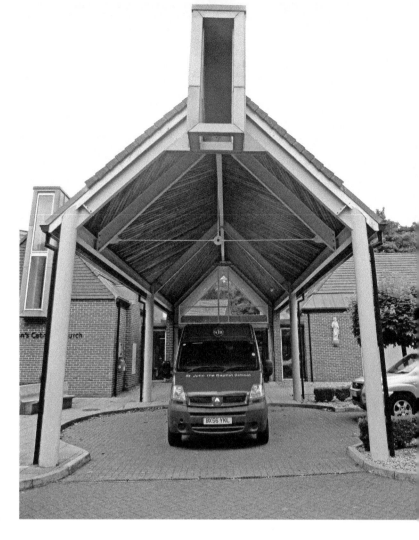

Entrance to
St Dunstan's Church.

32. Hoe Bridge School

Hoe Bridge School is an independent school set in 22 acres of woodland on the outskirts of Woking. It caters for about 500 hundred pupils aged from two to thirteen. The current building, a mixture of the historic and the modern, is on the site of Sir Edward Zouche's mansion, Hoe Place, built with material from the demolished Woking Palace. There are still some 2-inch Tudor bricks at the bottom of a wall in the extensive grounds. Surprisingly, the ceiling of the headmaster's study is a copy of the King's Bedchamber at Windsor Castle.

After Sir Edward's death, Hoe Place became a private residence. In the 1920s it was owned by the Booth family, who later sold it. In 1928 it became Hoe Place Preparatory School. In 1962 it merged with St Michael's School, which was situated at the corner of Woodham Road and Grange Road. Then in 1986 it joined Allen House in Guildford and became known as Hoe Bridge School – a name it still retains.

The current school contains a pre-preparatory department and a nursery originally housed in the old chapel. As numbers grew, the building was expanded and it is planned to make space available for a music and drama area.

Hoe Bridge School.

33. Robinsons Department Store

At one time Robinsons in Chertsey Road was the only department store in the town. It had originally been Alfred Wyles' Drapery Shop but in 1934 William Robinson bought it and gave it his name. On the upper floor he installed an excellent restaurant. He hired the same catering firm that served Harrods, the famous London department store, to provide the excellent food.

The ground floor contained a women's outfitters, which was very popular with elderly ladies who needed a new corset. They would be driven to the store by a chauffeur, who would summon a sales assistant and then go for a walk. The assistant would climb into the car to take the customer's measurements!

When William retired, the running of the store was taken over by his son, David, and daughter, Isabel. David became a prominent member of the local community. He was a Justice of the Peace, chairman of the Woking Borough Council in 1973 and was awarded an MBE by the Queen. Sadly, he died in December 2015.

With the redevelopment of Woking in the 1980s Robinsons closed and the site was eventually taken over by an estate agent. The distinctive upper part of the building remains the same.

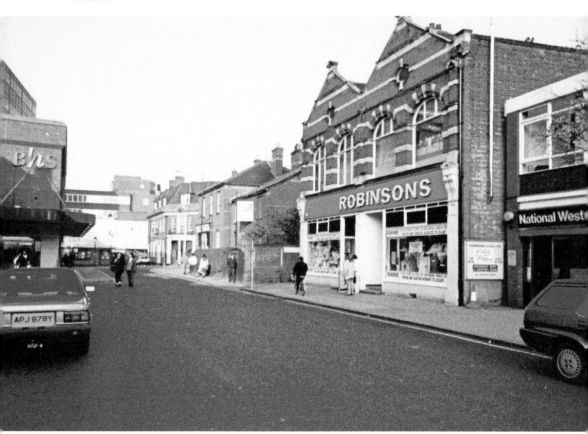

Robinsons department store.

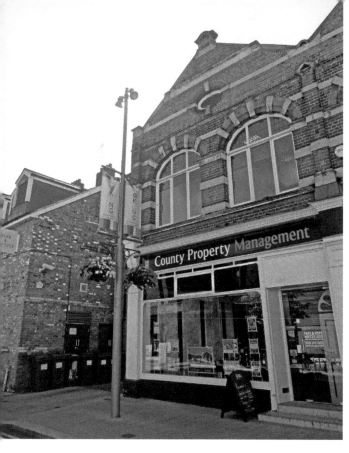

Estate agent.

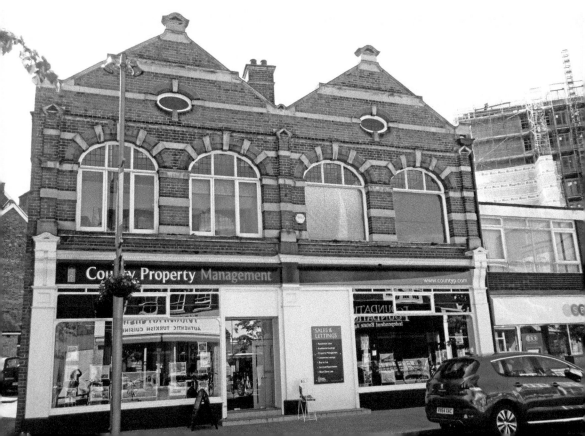

34. The Shaw Centre

In the 1930s the building in Chobham Road beside the Wheatsheaf Common was St Michael's School; this was a small private school run by a husband and wife. There is no doubt that it was the headmistress who was the dominant partner. She was fiery and was determined to run things her way. Her gentle, meek husband taught the younger children. Although both boys and girls were admitted to the school, the curriculum was biased towards the Common Entrance for Public Schools, which most of the boys took when they were thirteen. Exceptionally bright girls were taught with the boys but the rest of them were definitely 'second-class citizens'.

While the classrooms were small, there was plenty of space for sport as the Wheatsheaf Green was beside the school so the pupils did not have far to walk for their games lessons. In the 1940s bigger premises were required and Brynford, a large house on the corner of Grange Road and Woodham Road, was bought. The school took up residence in its new abode, a new teacher was appointed and, for the first time, the girls were given a fuller education. St Michael's later joined forces with the Hoe Bridge School on the Old Woking Road. Brynford was sold and houses were built in Brynford Close.

The building in Chobham Road remained and was later taken over by Surrey Social Services. It was adapted as a 'Contact Centre' and renamed the Shaw Centre. Supervisors can bring families to the centre where parents and grandparents can enjoy quality time with the children.

Shaw Centre.

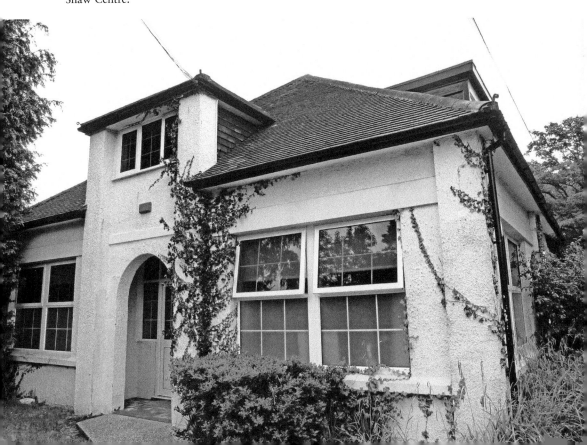

Shaw Centre.

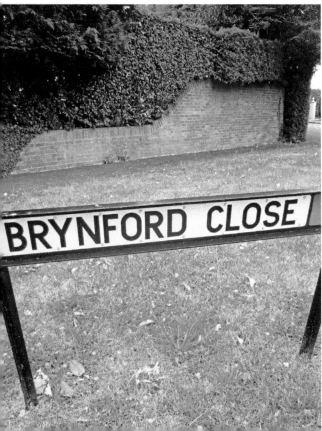

Brynford Close.

The rooms are bright and each is named after a colour: Blue, Indigo, Yellow, Orange and Green. The largest room, Red, contains a selection of toys, a bookcase full of appropriate books, a large sofa and a table tennis table. Beside the building, the spacious garden is a play area containing a variety of pieces of equipment for the children to climb on and enjoy. Surrey County Council employs nine staff to man the reception area and there is a small car park at the back to accommodate visitors.

35. St Andrew's School

In 1937 St Ann's School was founded in Mount Hermon Road. In 1947 it moved to Church Hill House in Horsell near the Church of St Mary the Virgin. The house was built in 1883 by John Bach, the current vicar, but he had never lived in it. Over the years it had many uses but in 1945 it was bought by Mr Walshan Maynard. The following year St Ann's School reopened as St Andrew's and in 1987 it became a charitable trust. Today it has over 300 pupils – both boys and girls – aged from three to thirteen.

Set in 11 acres of ground, there is ample space for a variety of sports at which the school excels. There are football and hockey pitches, tennis courts using the modern AstroTurf, cricket nets, an outdoor swimming pool and an athletics track. A daily schedule of PE and games is followed by all pupils and a number of clubs for various activities run throughout the year. Matches are played against neighbouring schools and there are regular inter-house competitions. Specialist coaching in the various sports is also available for enthusiastic pupils.

St Andrew's School.

Sign for St Andrew's School.

Chair made by pupils.

St Andrew's offers a varied balanced curriculum to fit pupils for the twenty-first century. As well as the basic 'core' subjects, it includes up-to-date technology, art and design, classics, drama and music. The busy music department is based in the Victorian part of the building and pupils play a variety of instruments and perform concerts to entertain parents and friends. Drama also plays a part and work from the various years is 'showcased' every year. Fascinating results from the art department are displayed around the school and a local artist sometimes visits.

Throughout the year pupils enjoy a variety of trips, which broaden their experience and supplement the curriculum. In the summer term a fair is held to raise money for various charities. Each year an impressive, detailed magazine is produced containing photographs, colourful artwork, examples of pupils' creative writing, results of matches and accounts of trips. It is a fascinating read that does great credit to an excellent school.

36. Hollywood House

The first cinema in Woking was opened in 1903 and the second in 1913. The third one, said to be 'one of the finest cinemas in the United Kingdom', was the last word in luxury. This was the Ritz, built by Union Cinemas in Chobham Road. It was officially opened on 12 April 1930 by Mr Godfrey Nicholson, the Member of Parliament for Farnham. The builders had taken advantage of the advances in technology for the projection of the films. Central heating and air conditioning ensured the comfort of visitors and, at great expense, a specially built Compton organ was installed. The first film to be shown was *The Texas Rangers*, followed by a comedy, *Wives Never Know*.

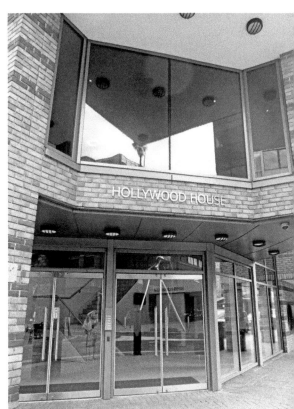

Hollywood House.

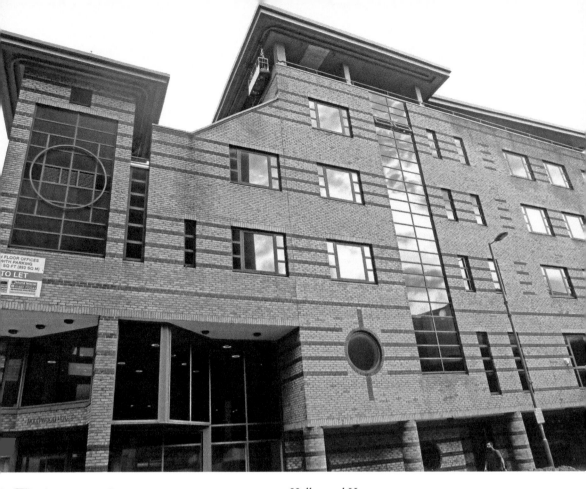

Hollywood House.

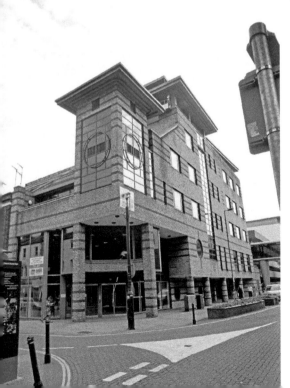

The upper floor of the building housed a restaurant, and, at matinee performances, members of the audience had afternoon tea brought to them in their seats. Non-cinemagoers were also welcome to patronise the restaurant.

With the advent of television, cinemas became less popular and, sadly, the Ritz Cinema closed and was later used as a bingo hall. The building was demolished in 1988 and an office block was built on the site. It was given the name of Hollywood House as a reminder of the 'Silver Screen'.

37. Bridge Barn

Bridge Barn, situated on the banks of the Basingstoke Canal, was probably built in the sixteenth century. Parts of the old building still remain. As its name suggests, it was originally a farm building. In the nineteenth century Slococks established a nursery garden in Goldsworth Road. As the 'barn' was no longer used as a farm building, it was taken over to be used as a small nursery. A small ivy-covered cottage named Bridge Barn stood nearby.

During the second half of the nineteenth century and the early part of the twentieth the area was developed and new roads were built including Arthur's Bridge Road beside Bridge Barn. The nursery continued to function until the mid-twentieth century when a riding school was established on the site. This flourished for several years. Meanwhile, Woking had continued to grow and, because of the increase in the number of cars, a new road was

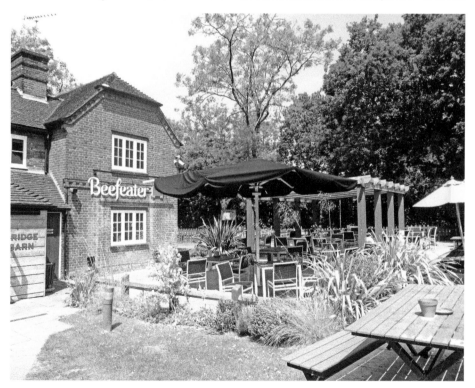

Bridge Barn.

Bridge Barn.

Bar area.

built and Arthur's Bridge Road was closed. The cul-de-sac created was renamed Bridge Barn Lane and Bridge Barn became a restaurant, which has changed hands several times.

Today it is a Beefeater. There is a Premier Inn nearby so guests can walk across to the restaurant and enjoy a delicious cooked or continental breakfast. Regular visitors to the restaurant can join the Reward Club, which entitles the holder to discounts and 'special offers'. Five points are awarded for every pound spent and when this reaches 5,000 a £5 voucher is awarded.

The downstairs bar area contains a number of tables. On summer days visitors can also sit in the garden beside the canal. Upstairs, the restaurant is on two levels; there are small tables for two as well as larger ones for family parties. Some are situated beside windows with a view of the canal. The Beefeater encourages visitors with a variety of offers during the less busy times of the day. Occasionally there is a 40 per cent discount on main meals and in April 2017 these were being offered for only £5! Those who own a Reward Card can also claim a free meal on their birthday.

38. St Michael's Church

At the end of the Second World War much of London was in ruins and many families had lost their homes. A number of new neighbourhoods were created to house the homeless Londoners. One of these was the Sheerwater estate, which was built in the 1950s on woodland between the railway line and the Basingstoke Canal.

The original plans provided for the building of three Christian churches for Catholics, Anglicans and Methodists. However, these were only temporary structures and it was intended to erect permanent buildings at a later stage. This did not happen and by the middle of the 1960s all the buildings were in dire need of repair.

St Michael's Church, Sheerwater.

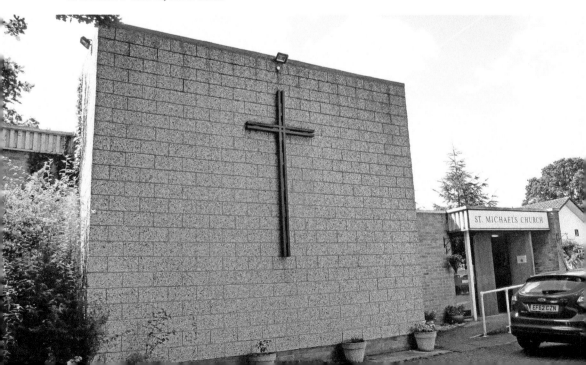

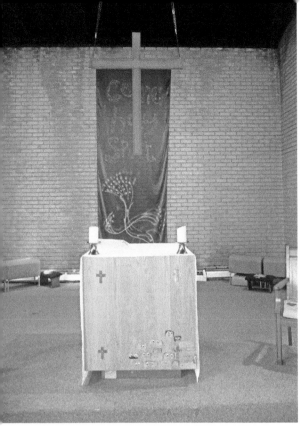

Inside St Michael's Church.

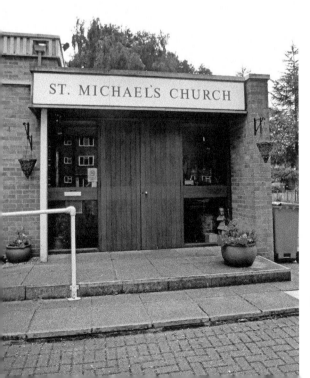

Entrance to St Michael's Church.

The Catholic church was closed and worshippers joined the congregation at St Dunstan's Church near the railway station. The Anglican and Methodist churches were both demolished. It was decided that one new church would be built and this would be used by both Anglicans and Methodists. St Michael's Church in Sheerwater was dedicated on 24 April 1976. It became the daughter church of All Saints' Church, Woodham, as it was in that parish. At first separate services were held by the two congregations but gradually they became combined. The building was also used for other purposes by the local community. In 2011 the kitchen was upgraded so that it was in line with modern health standards.

Over the next few years there were plans for redeveloping Sheerwater. While St Michael's is still part of the parish of All Saints, Woodham, there is less communication than there was in previous years. In June 2016 Revd Gillaine Holland was appointed as the new vicar. Today the church continues to be used by both Methodists and Anglicans. In 2017 the Methodist minister led the Mothering Sunday service and on Palm Sunday the Bishop of Guildford led a confirmation service. The weekly Sunday service is followed by coffee and once a month a 'proper Sunday lunch' can be enjoyed for a small fee.

During the week other activities take place. Groups meet to keep fit, to experiment with arts and crafts, to paint, or just to chat.

39. The Maybury Centre

Since the Second World War Woking has become a multicultural town and Maybury, particularly, has a large ethnic population. In 1987 the Central and Maybury Community Association was founded. This campaigned for a community centre where people from different backgrounds, cultures and faiths could meet. Woking Borough Council was sympathetic and a property was found in Board School Road. This had been built in the 1870s as one of the board schools and in the twentieth century it had become Maybury Infant School. In 1988 negotiations started to buy the property but it was not until 1993 that these were completed and work on converting the building could begin. By the following year the Maybury Centre was open for business. It consisted of a large main hall, two smaller halls, a number of classrooms, a modern kitchen and a few smaller rooms for more intimate meetings. On 28 September 1994 the centre was officially opened by Sir Trevor MacDonald.

Today it is a hive of activity with seventy-five individuals or organisations using it on a regular basis. Liaise is a multicultural women's group that offers language classes as well as advice; The School Project organises a variety of activities for young people. The centre is also used by the Little Lane Pre-School, the Woking Pakistan Muslim Welfare Association and Woking College. Recreational groups include operatic, drama and dance societies, who make use of the main hall. Those less energetic can concentrate on yoga and play Scrabble in the smaller spaces. Coffee mornings and social events are popular and those with disabilities are catered for; the 'loop' system as well as Wi-Fi is available. The centre is grateful for the continued support of Woking Borough Council, which helps to fund some of the activities.

Since its opening in 1994, it has adapted and changed to meet the needs of an ever-growing population and, in the twenty-first century, it continues to meet the needs of the people from the variety of cultures that comprise the local community. As it is close to the town centre, it is easily accessible.

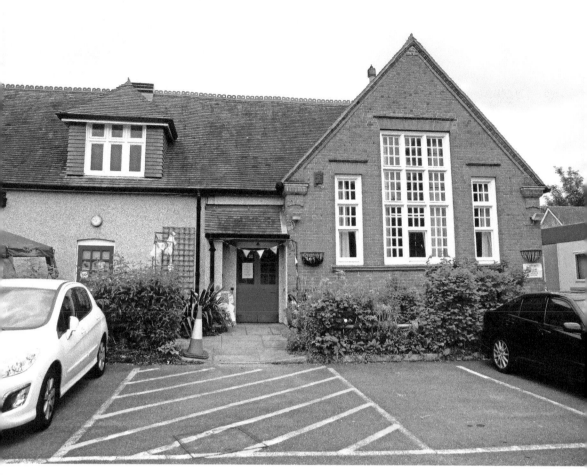

The Maybury Centre.

40. The Surrey History Centre

Goldsworth Road gave its name to Goldsworth School, a primary school that served the area for many years. When the school grew in numbers, new premises were needed and these were found in Bridge Barn Lane. A new purpose-built school was erected to serve the needs of the twentieth century. It continues to do so in the twenty-first century.

The county of Surrey has a long and fascinating history and for some time a single building to house documents, books, maps and other artefacts had been needed. The unoccupied site in Goldsworth Road was ideal. The old school was demolished and an impressive new building was erected in its place; it was given the name of the Surrey History Centre. When it was completed, material was collected from around the county.

Today the centre contains a wealth of material illustrating Surrey's history from the twelfth to the twenty-first centuries. The strong room holds 6 miles of records! There are ancient documents, maps, books, photographs, newspapers, magazines and other memorabilia. Some of the documents have been put on microfilm for easy access.

The centre is open from Tuesday to Saturday but is closed on Bank Holidays. Entrance is free but to access research material, visitors have to produce a Surrey Library card. All bags have to put in lockers and only pencils and notebooks may be taken into the library. This is usually a hive of activity. Assistants are on hand to 'order' the books or documents required and there are bookrests on the tables.

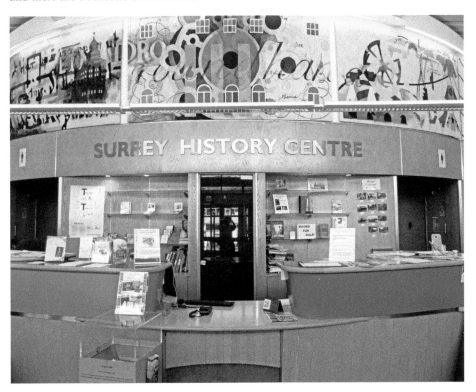

The foyer in Surrey History Centre.

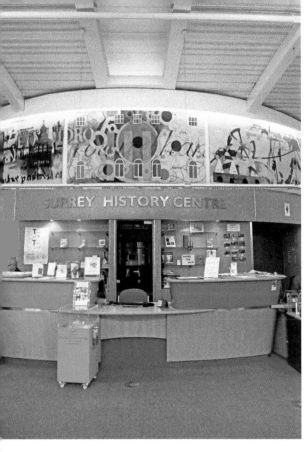

The foyer.

Entrance to Surrey History Centre.

The centre is not only used for research. The reception hall contains a small bookshop selling books about Surrey by local authors. Throughout the year talks by experts are given and exhibitions are held to commemorate specific anniversaries. Each month an exhibition celebrating 'Marvels of the Month' is produced by the Surrey Heritage Team. Some of these have been: 'Gypsies in Surrey', 'A Loyalist's relics of King Charles II in exile' and 'Artists and Writers who found inspiration in the Surrey Landscape'.

More material is constantly being donated and this will no doubt continue.

41. The Ambassadors

Until the 1970s plays and concerts in Woking were held in Christ Church Hall. There was a stage at one end but the seats were not tiered and the sound was not good. In the 1970s part of Woking was redeveloped. Christ Church Hall was demolished and in 1975 a new purpose-built theatre was built on the site. Named the Rhoda McGaw Theatre after a well-known Woking councillor, it seated 230. At first it was part of the Centre Halls Complex but, in the 1990s, this too was demolished to make way for a new huge theatre complex.

At first there was some doubt as to whether the Rhoda McGaw Theatre would survive. However, thanks to overwhelming public support and the efforts of some councillors, the developers were persuaded to retain the small theatre, although it was relegated to the basement of the complex. Nevertheless, it continues to entertain audiences on a regular basis.

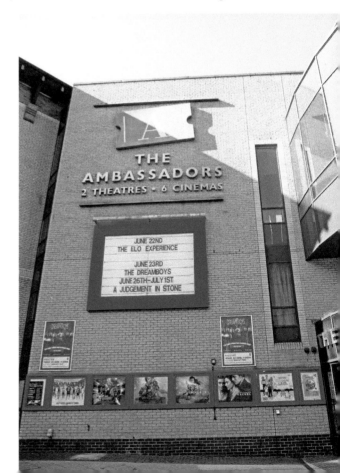

The Ambassadors.

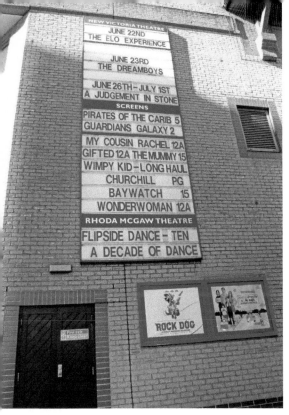

Left: The Ambassadors' programme.

Below: The Ambassadors complex.

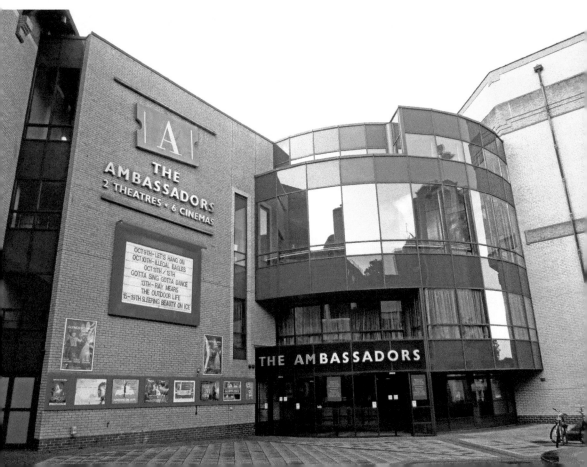

To prove its worth, the newly formed Rhoda McGaw Company put on 'a stunning theatrical kaleidoscope' entitled *Encore* to celebrate the millennium. With a large cast of actors, singers, dancers and musicians, it performed to packed audiences for several days.

The huge Victoria Theatre, which occupies the higher floors of the Ambassadors complex, seats 2,000 and audiences are regularly entertained to musicals, operas and occasionally plays. The loud music frequently seeps through to the Rhoda McGaw Theatre below. Bars are situated near the theatre. The first floor of the complex contains the box office and nearby the Auberge Restaurant caters both for theatregoers and for the general public.

As well as the two theatres, the Ambassadors boasts six cinema screens, which perform daily, showing the latest films, although during the earlier performances many of the seats remain empty. Popcorn and sweets are sold at the entrance to the cinema screens.

A car park occupies the three floors above so members of the audience can walk from their cars to the theatre or cinema without having to go outside – a big advantage when it is raining.

42. H. G. Wells Centre

H. G. Wells, the famous novelist, is recognised as one of Woking's most important residents, although he only lived in the town for a short time. Having divorced his first wife Isabel, he took a mistress, Amy Catherine Robins. She was known as Jane and in 1895 he moved with her to 'Lynton', a small house in Maybury Road, which now contains his name on the blue plaque on the wall. He married Jane in October and, while in Woking, he wrote his famous book, *War of the Worlds*. As it contained a graphic description of the destruction of Woking by Martian aliens, perhaps it is not surprising that he left the town soon after it was published in 1898!

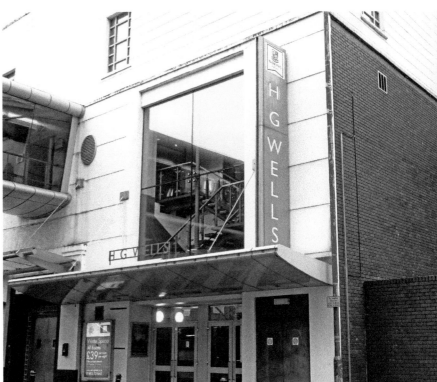

The H. G. Wells Centre.

Left: Entrance to the centre.

Right: H. G. Wells Centre.

A century after the publication of the book, Woking commemorated her famous son. The H. G. Wells Centre was erected in Commercial Road. In the twenty-first century this is still as popular as it was when it first opened. Described as the 'Number One Venue' in the town, it contains a number of conference rooms as well as larger venues for concerts. It can cater for up to 800 guests and catering is available in house so those hosting events have no need to employ outside caterers. A variety of events are held at the centre; there are conferences, exhibitions, product launches, dances, parties, anniversary celebrations and, of course, concerts.

Nearby in Crown Passage stands *The Martian Landing*, a stainless-steel statue that is an excellent representation of one of the 'Martians' who destroyed Woking. Seven metres tall, it was unveiled on 8 April 1998 by Carol Vorderman, the television presenter.

H. G. Wells was born in 1866. In 2016, a number of events were held in the town to celebrate the 150th anniversary of his birth. A new statue of the novelist by local artist Wesley H. Harland entitled *H. G. Well Novelist and Thinker* was unveiled outside the Lightbox. Later, this will be moved to the town centre where it will form part of the 'Wells in Woking Heritage Trail'. Woking's most famous son will not be forgotten.

43. The Big Apple

The Big Apple appeared in Woking towards the end of the twentieth century. Described as the 'top local venue for a wide range of exciting entertainment', it is situated in Commercial

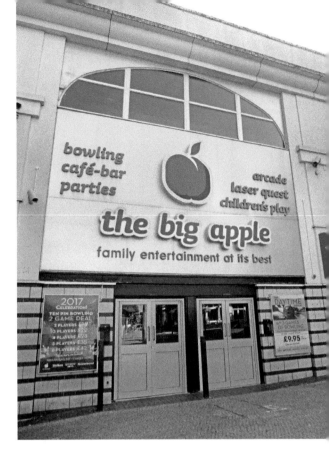

The Big Apple.

Way. Boasting a number of 'amusements', it caters for all ages and there is easy access for wheelchair users.

Tenpin bowling has become very popular and the Big Apple contains all the latest equipment including lane-bumpers and ball ramps. The balls are of different weights while the finger holes vary to suit all ages from toddlers to adults. Help is available for absolute beginners and suitable kit is also provided. Bowling parties are becoming a popular way to celebrate children's birthdays.

In a large multi-level, maze-like arena scattered with ramps and catwalks, visitors can enjoy the more energetic Laserquest. This is an indoor lasertag team game using hand-held laser 'guns' and wearing 'vests' made of heavy duty material and worn over the shoulders. These are dotted with sensors, which also appear on the 'gun'. Before starting to play, all players are instructed about the strict playing code. There must be no physical contact and there should be no 'running, jumping or lying down'. A marshal from the Big Apple ensures fair play. The aim of the game is to tag the sensors on as many members of the opposite team as possible while avoiding being 'tagged' oneself. This is often difficult when the arena is shrouded in fog and strobe lights hover! Numbers are limited to thirty-six and anyone from the age of six upwards can take part. It is particularly popular with teenagers. As it is played in teams, companies sometimes use it to encourage employees to work together.

The third area is the Planet Zoom, described as 'fun and magic for kids'. There are snake slides, fun activities towers and colourful ball parks. The xone is safe and secure and an employee of the Big Apple is always on hand to oversee the proceedings. Parents can sit and watch from a designated area while enjoying refreshments from the café.

The Big Apple.

44. The Peacocks Shopping Centre

The Ambassadors leads to the Peacocks, a shopping centre that was also part of the development in the 1970s. From the car park on the first floor, a lift takes the visitor down to the upper, lower or basement floors. Originally the site contained one of Woking's iconic buildings, the Atalanta Ballroom. At one time a Methodist manse and then the headquarters of the YMCA, it transformed itself into a ballroom with the introduction of an excellent sprung floor for dancing. It acquired a resident band and, for years, it was a popular venue for dances, concerts and discos. Many famous bands performed there including the Rolling Stones.

When the Atalanta was scheduled for demolition in the 1970s there was a public outcry and a petition was delivered to the council. However, the public's wishes were ignored and the building was demolished in 1972 to make room for the new shopping centre. Today the two shopping floors of the Peacocks contain a variety of shops including jewellers, clothes shops, Wilco, Primark and Debenhams department store. On the upper floor, a stately peacock glares down at the shoppers. Above the shops, four floors provide plenty of space for parking cars. The basement is a food hall with a variety of eating places. The vast hall is filled with tables and chairs while the food counters are around the outside. On offer are pizzas, jacket potatoes, burgers and even a delicatessen selling mouth-watering pastries and cakes. Also in the basement opposite the lift is a large TK Maxx with its variety of goods. The shops in the Peacocks open at 9.30, which is slightly later than other parts of the town.

An escalator on the lower floor leads to a walkway between shops including a 'muffin café'. At the exit Toys R Us fill one side while Burger King is on the other. The exit leads to one end of the town. On the upper floor at the opposite side of the Peacocks, another shop-strewn walkway leads out of the mall towards Christ Church and the war memorial.

The Peacocks Shopping Centre.

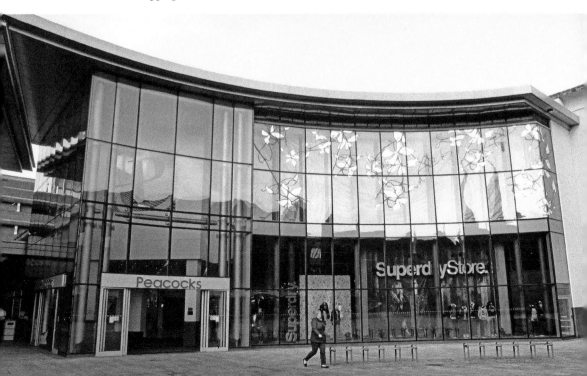

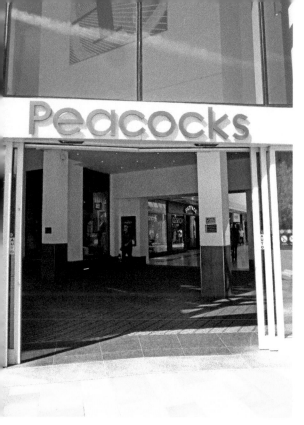
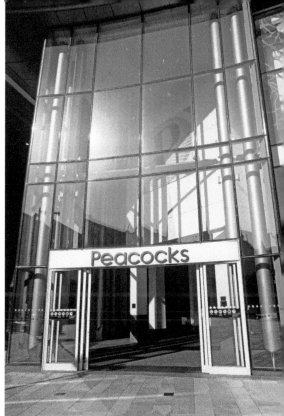

The Peacocks.

45. David Lloyd Leisure Centre

In 1976 Chris Lane had a dream: he wanted to open a leisure club where families could enjoy a variety of sports in a safe environment. But his ambition and enthusiasm were not enough. He had to become a businessman, banks had to be approached for finance, and appropriate sites had to be found. He persevered for nine long years before his dream became a reality.

In 1985 the Chris Lane Leisure Centre opened in Westfield Avenue. To start with there were four indoor tennis courts under a plastic dome. A small club room was nearby. Over the years the club expanded and grew into a successful business with a reputation for excellence. As the twenty-first century dawned, there were nearly 5,000 adult members and over 1,000 juniors. Four more indoors courts and four outdoor courts had been added. There was also an exercise studio, a gym and a health and beauty spa.

In 2002 the Chris Lane Leisure Centre was sold to Whitbread, who had developed the David Lloyd Centres. The club became the David Lloyd Leisure Centre. Its reputation for excellence continued. A number of tennis professionals were employed and competitions were introduced. There were men's teams, ladies' teams and mixed doubles. There were also 'club sessions' for those who preferred a more social game. More family activities were introduced and the club continued to expand. The gym is also very popular. Members of both sexes can often be seen pounding the treadmill before going to work!

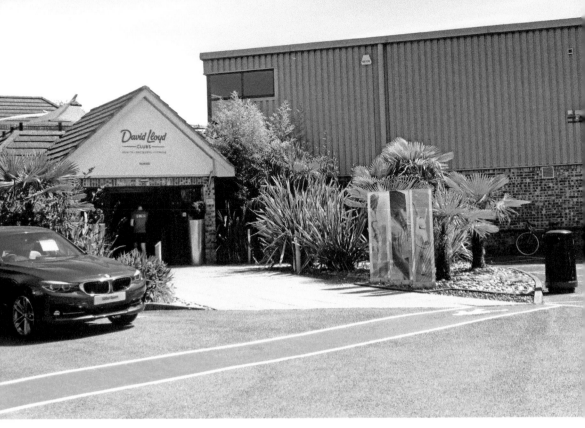

David Lloyd Leisure Centre.

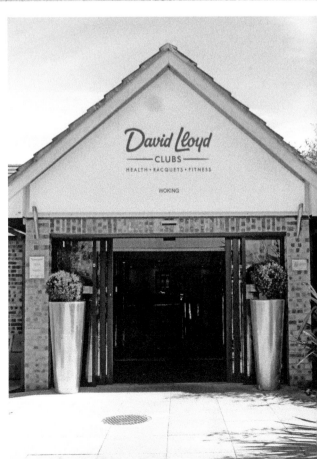

David Lloyd sign.

Beside the swimming pool, a sauna and steam room were added; the health and beauty spa disappeared but a physiotherapy room was introduced. An extra studio provides space for a variety of activities: Zumba, yoga, Pilates, body balance and others. A crèche was provided and more activities for young ones were introduced. In the summer holidays a variety of children's camps are held.

The café, appropriately named DLICIOUS, provides a 'balanced choice of meals and snacks to complement a healthy life style'. There is plenty of variety and there is even a kids' meal deal; this comprises 'any main, dessert and drink for £5.95'.

Twenty-first Century

46. The Lightbox

One of the most striking new buildings in Woking is the Lightbox. This was the brainchild of the enterprising Woking History Society. In 1993 the society decided that, as the town had a long association with music and drama, it was time it also had a cultural centre. The Woking Borough Council was sympathetic to the idea and fundraising started but it was not until the twenty-first century that the dream became a reality.

As well as donations from local residents, Woking Borough Council and the Heritage Lottery Fund contributed. A site was found on the corner of Chobham Road and Victoria Way on the banks of the Basingstoke Canal. The architect chosen had also designed the London Eye. The unusual square brick box incorporating three galleries was completed in 2007. The following year it was officially opened by the Duke of York. It was immediately recognised as an important new venture and the same year it was awarded the prestigious Museum of the Year award.

The Lightbox.

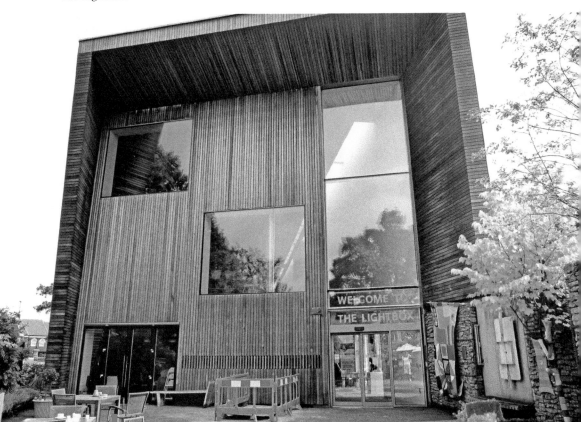

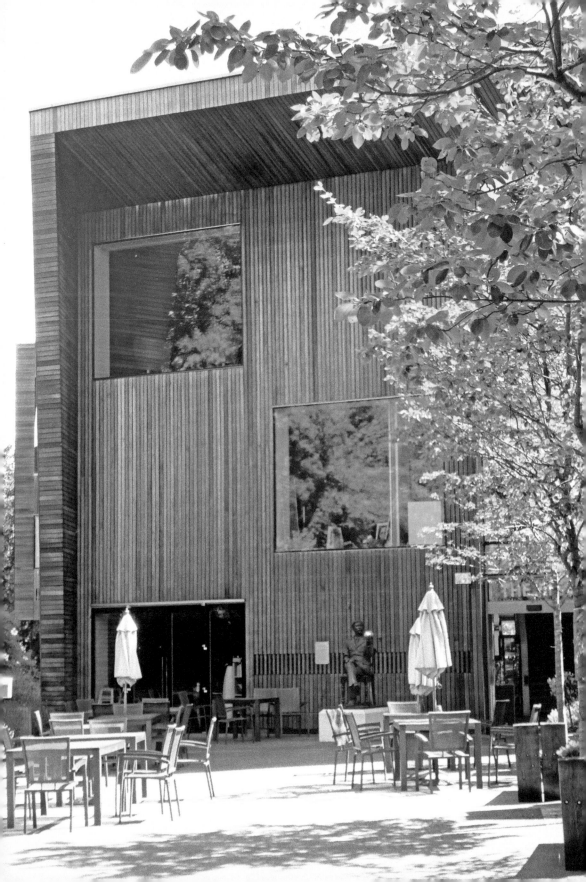

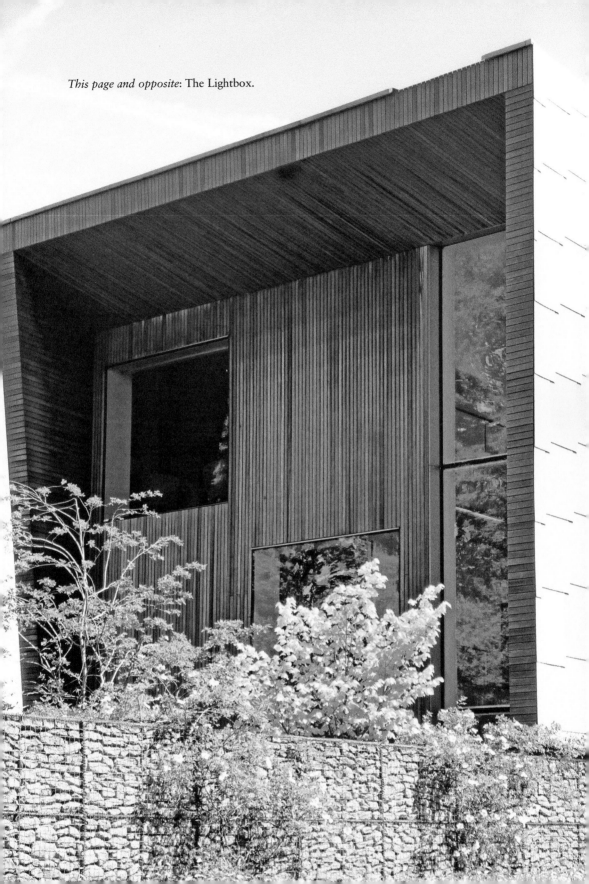

This page and opposite: The Lightbox.

The Museum and Cultural Centre soon became popular both with local residents and visitors from farther afield. On the ground floor a café provides light meals and behind this, the shop sells local books, cards and gifts. A wide staircase and a lift leads to the upper floor, which houses a permanent exhibition of Woking's history that is frequently updated by a band of enthusiastic volunteers. Throughout the year there are lectures, workshops and other events both for adults and children. A number of fascinating temporary exhibitions are also held. A volunteer is always on hand to assist visitors and some rooms are available for hire.

The year 2017 was an exciting year for the Lightbox as Woking's first literary festival was held there. This incorporated a pop-up bookshop, talks from local authors, activities for families, a fascinating talk by an author who had introduced Shakespeare to Swahililand and even a Regency dinner to celebrate the 200th anniversary of the death of Jane Austen. It is hoped that this successful literary festival will become an annual event.

47. Patisserie Valerie

A popular restaurant situated in Wolsey Place is Patisserie Valerie. The chain was founded by Belgian-born Madame Valerie, who felt that England's 'plain fare' should be supplemented by delicious continental pastries. 'Patisserie' is the French for pastry and it is for these pastries that the café became famous. The first Patisserie opened in Frith Street in London in 1926. When, during the Second World War, the shop was bombed, a new site was found in Old Compton Street.

In 1987 the shop was sold and, under the new owners, more branches were opened in other parts of the country. Patisserie Valerie opened in Wolsey Place in Woking in September 2013. Here, at any time of the day, customers can sit in comfortable armchairs and relax alone or with friends while enjoying some of the delicious cosmopolitan delights on the extensive menu.

Although of continental origin, a full English breakfast is served all day. A little later, on offer is a brunch, grilled snacks and a two- or three-course lunch menu. During the summer, a summer menu appears. There is also a separate children's menu, which is attractively produced. The patisserie menu contains illustrations of the delightful concoctions that are on display in the window persuading passers-by to stop and indulge. If the customer has no time to sit and relax, a patisserie can be packed into an attractive box and enjoyed later at home.

Those who have time to spare during the afternoon can indulge in a Madame Valerie Cream Tea. This consists of traditional finger sandwiches, scones with clotted cream and jam and mini versions of mouth-watering patisseries. For those who wish for a special cake to celebrate a particular anniversary, a cake can be produced to your specifications. This can also be ordered online. There is even a step-by-step process by which you can create your own concoction from a variety of choices.

Valerie Patisserie opens every day at 8 o'clock and closes at 7 o'clock. The exception is Sunday when it opens at 10 a.m. and closes at 5 p.m. Thursday is late night shopping so the closing time is 8 p.m.

Patisserie Valerie.

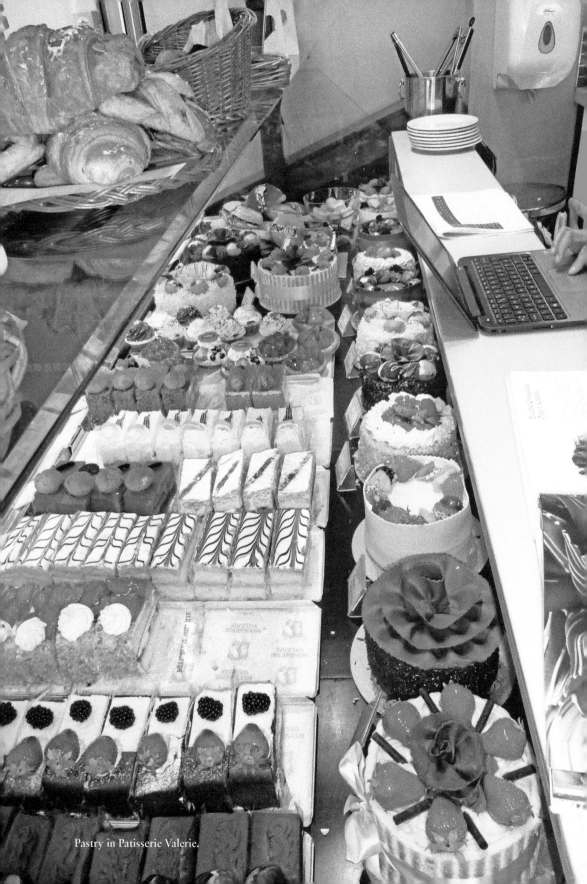

Pastry in Patisserie Valerie.

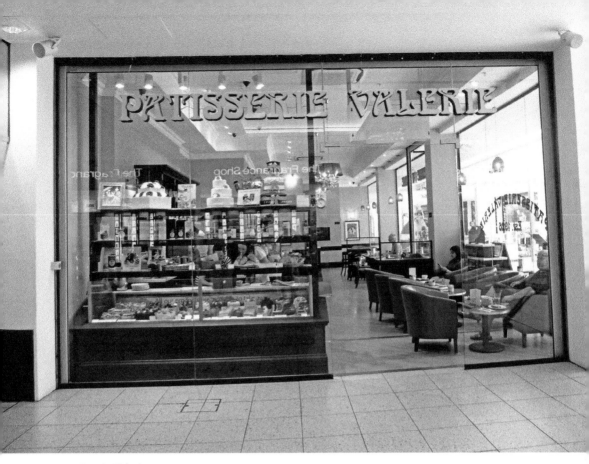

Patisserie Valerie.

48. The Living Planet Centre

A fascinating building opposite the Lightbox is the Living Planet Centre opened in November 2013 by Sir David Attenborough. Its curved roof and metal girders stretch from the banks of the canal to Brewery Road. The headquarters of the World Wildlife Fund, its four interactive zones each focus on a key theme – forests, rivers, oceans and wildlife. In each zone are several touchscreens enabling both adults and children to explore the world in which we live. Specially commissioned films and soundtracks are used to evoke the sights and sounds of the diverse natural environments.

The Learning Zone with space for thirty-five pupils and teachers contains a smartboard, ipads, desks, art tools and cameras. School groups, aged between seven and eleven, often visit to supplement the work they are doing in the classroom. They take part in workshops where they develop practical skills and learn about crucial 'green' issues.

An environmentally friendly building, the rural and the urban are linked by the clever use of landscaping. Many trees have been retained on the site. Wildlife is attracted to the area through the strategic positioning of bird, bug and bat boxes. The plants around the building draw butterflies and other small creatures towards them. Throughout the area technology has been maximised to improve productivity and monitor the building. Plants and fig trees help to keep the air clean inside; Energain insulation in the roof captures the

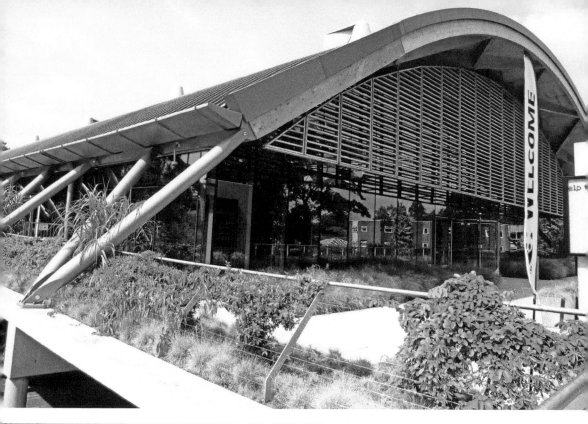

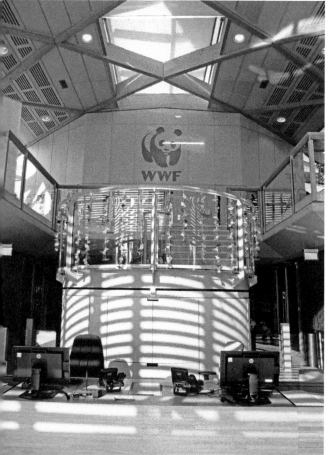

Above: The Living Planet Centre.

Left: Inside the Living Planet Centre.

Board outside the Living Planet Centre.

heat during the day and releases it when the sun goes down. Sound is absorbed by the roof panels and birdsong can be heard around the open plan area. Windows let in natural light and LED lighting is used when needed.

The building is heated through a system of earth ducts and ground-source heat pipes. Wind cowls on the roof aid natural ventilation while the need for electricity is reduced by the use of solar panels. 'Grey water' from sinks is reused and rainwater is collected. Waste is recycled or composted and the remainder used for energy recovery. Entry to the Living Planet Centre is free and it is well worth a visit.

49. The Tante Marie Academy and Restaurant

The Tante Marie Restaurant first opened its doors to the public in Woking in 2015. It has since become a popular venue in which to enjoy excellent food that is reasonably priced. Its roots are in the twentieth century. The Tante Marie Culinary Academy was established in Woking in 1954 by Iris Syrett, a cookery writer. It was the United Kingdom's oldest independent cookery school. Iris died in 1964 but the school continued under new management and in 1967 it moved to Woodham House in Carlton Road where it continued to offer a variety of courses to aspiring chefs.

With the redevelopment of Woking in the twenty-first century, it was decided to relocate the academy to the town centre. It took over Alexander House in Commercial Way and refurbished it to suit the demands of the twenty-first century. The academy awards diplomas in Cordon Bleu Cookery and Hospitality Management. When the Tante Marie Restaurant opened next to the academy in April 2015, graduates continued their training as paid apprentices in the restaurant. Many then left Woking to pursue successful careers elsewhere in catering and hospitality. Gap year courses, which can be counted towards the Duke of Edinburgh's Award, are also available. These qualify students to take seasonal jobs in hotels and many take advantage of this.

Tante Marie Academy and Restaurant.

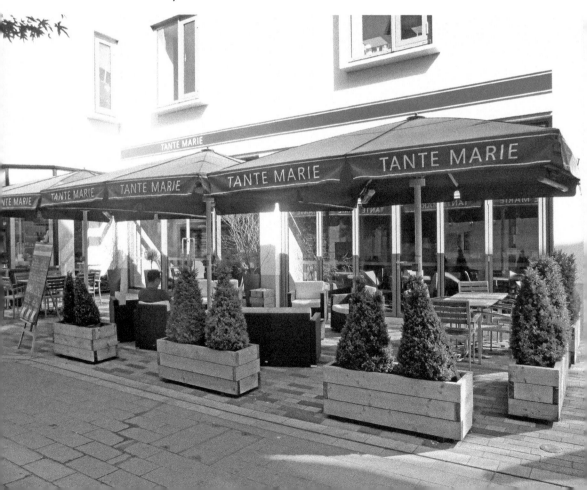

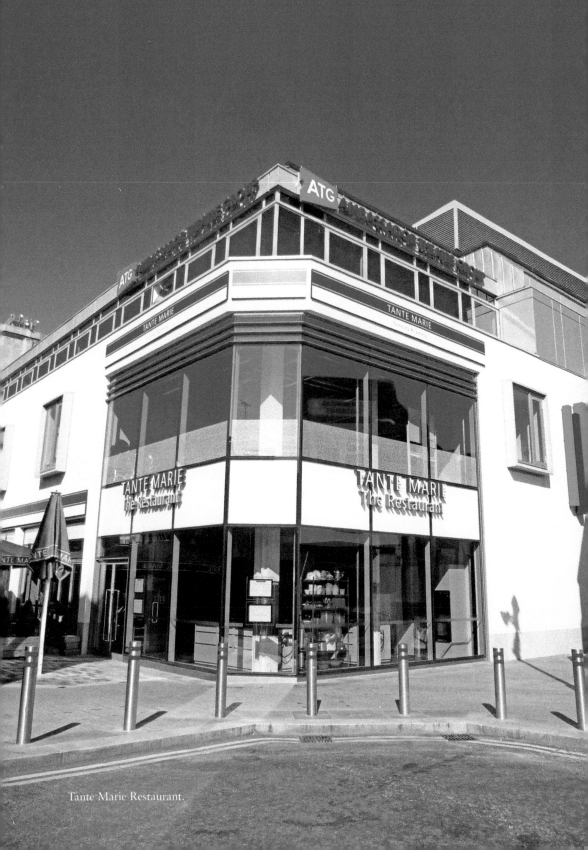

Tante Marie Restaurant.

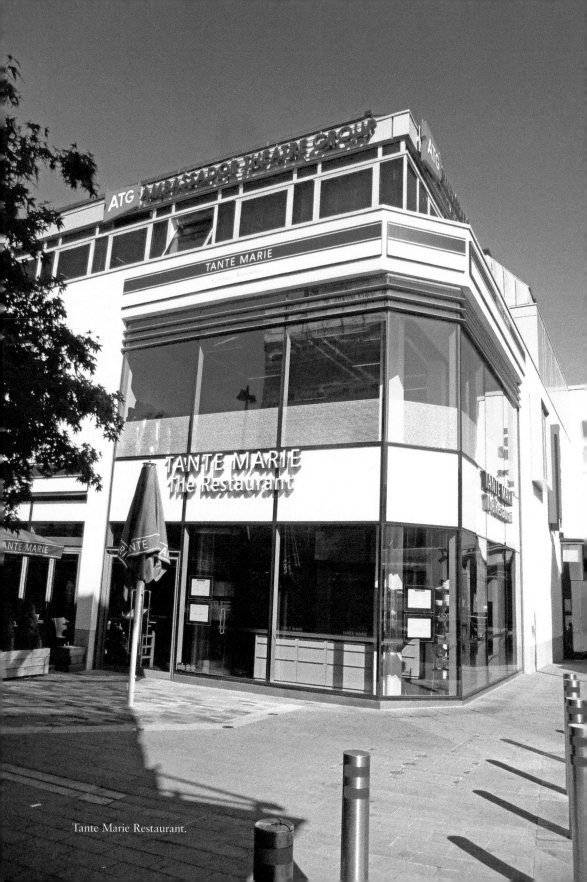

Tante Marie Restaurant.

At one end of the restaurant is Tante Marie Live, a teaching kitchen; here a wide a variety of courses are held to cater for all abilities. They are run during the day, in evenings and also at weekends. As the kitchen can only accommodate a maximum of eight students, the courses are limited to this number. There is plenty to cater for all tastes; students can prepare an Indonesian banquet, learn knife skills, perfect their pasta, master their macarons and indulge in a creative Christmas. There are also classes for 'men only' and for children. In the restaurant the public can enjoy delicious lunches and dinners; even brunch is available at the weekends. The restaurant can also be hired by individuals or companies for private events.

50. The Bird in Hand

Once a landmark in Mayford, the Bird in Hand has always been a public house owned by individuals. At one time it was owned by a Mr Enzo, who also owned Enzo's wine bar. During his time the pub flourished and it was he who built the extension on to the original building. This is now the restaurant, which is separate from the bar area. Later, it was taken over by other owners but, sadly, by the twenty-first century its popularity had diminished and it needed a great deal of care to restore it.

The Bird in Hand.

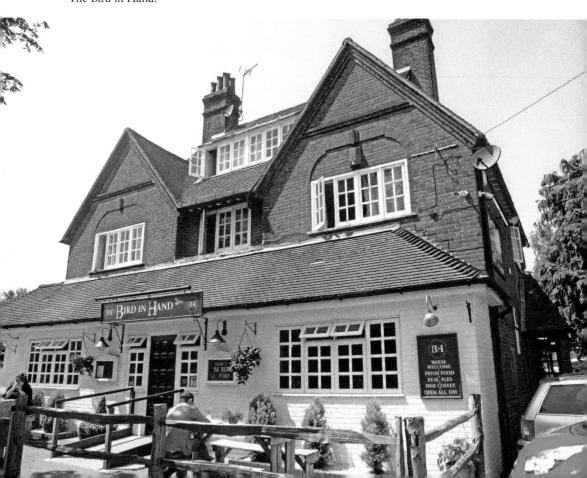

Bar in the Bird in Hand.

Enter two enterprising young men. Not only were they not part of one of the many chains, but they were local. Markus Hebbourn and Mike Cumberland had worked in other local pubs and decided to take over the Bird in Hand and make it as popular as it had once been. They tackled their new venture with great enthusiasm. Extensive renovation was carried out to restore the pub to its former glory.

In October 2015 the Bird in Hand was once again open for business. Described as 'cosy and casual', its rustic décor is enhanced by an open fire to provide comfort in the winter months. Comfortable sofas as well as intimate corners for private conversations are provided in the well-stocked bar area. In the spacious dining room light comes from the skylights and Edison lamps. Paintings of bygone days grace the pale walls while potted plants scattered around provide splashes of colour.

The menu is extensive and experimental, avoiding many of the staple dishes of the more traditional pubs. At lunch time a selection of sandwiches and wraps are available and also small plates as well as larger ones. Among other delights for dessert, a traditional banana split is 'caramalised' and served with a milli-feuille wafer. Each Sunday, the meat offered for the traditional Sunday roast varies.

The Bird in Hand also offers a variety of evening events including a tapas night, a steak and cheese night and wine tastings. There is something for everyone in this recently renovated, very popular pub.